IMAGES
of America

The Italian Americans of
GREATER
BOSTON
A Proud Tradition

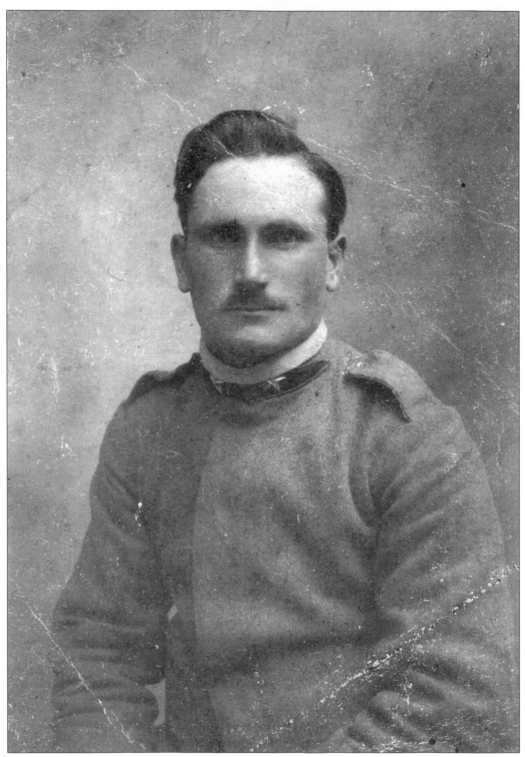

Loreto Salvucci, the author's maternal grandfather, poses in the uniform of a World War I Italian soldier.

IMAGES
of America

THE ITALIAN AMERICANS OF
GREATER
BOSTON
A PROUD TRADITION

William P. Marchione, Ph.D.

ARCADIA

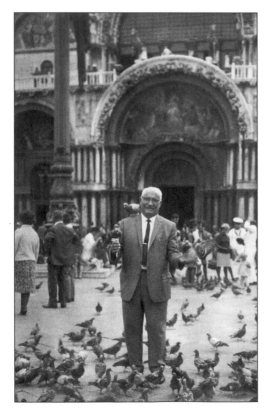

Loreto Salvucci stands in St. Mark's Square, Venice, in 1966 during his first trip back to his homeland in 42 years. (Courtesy of Antonetta Salvucci.)

CONTENTS

ACKNOWLEDGMENTS

This book developed out of a lecture series that I presented in late 1995 to the Center for Italian Culture (CIC). These were lectures that I had hoped would help fill an historical void, since no one had previously provided an overall account of the history of Greater Boston's Italian community. I am most grateful to the CIC for furnishing the initial audience for that lecture series. In the more than three years that followed, the lectures were repeated to many audiences throughout the Greater Boston area, and the response was invariably enthusiastic. Clearly, Italian Americans were curious to know more about the history of their ethnic group.

I could not have put this volume together without the help of many generous and supportive people. The great majority of the images that appear in these pages came out of private photographic collections, and thus, they are receiving their first public exposure in this volume.

I want, in particular, to acknowledge the assistance I received from the following individuals who either provided material or pointed me in productive directions: Vito Aluia, Jean (Burgarella) Anjoorian, Laura (Pepi) Bain, Marie (Marchi) Bonello, Elaine Cobucci, Guy Ciannavei, James Campano, Elisa Ciampa, Cleto Crognale, Francine Crognale, Mary (Antonellis) Cuggino, Connie (Tocci) Cummings, Eugenia (Pepi) Cummings, James Cummings, Sylvia Curato, Geraldine Curatolo, Mario Curatolo, Elvira (Sordillo) DeAngelis, Paul DeAngelis, Marge (Panarello) DiSciullo, Margherita (DiDuca) Drake, Doris (Lavilli) Duff, Anna (Vinti) Edmonson, Kathryn (Morano) Farrell, Father Carney Gavin, Jimmy (Bono) Geany, Roseann (Cerbone) Innes, Laura (Tocci) LaCroix, Betty (Totino) Lasden, Nicola Leone, Bob Leverone, Bud Lombardi, Joseph LoPiccolo, Vivian Lorenzoni, Alfred Marchioni, Esther (Tocci) Marchioni, Anna (Tocci) Marzilli, Rocco Marzilli, Emilio Mazzola, Terri Mazzuli, Marcia (Yannizze) Melnyk, Dan Miranda, Anthony Pellegrini, Gloria (Tofanelli) Puccini, Mary (Tocci) Regan, Anthony Ricciardi, Jeanne (Russo) Richards, Erdna (Reggio) Rogers, Adeline (Perruzza) Rufo, Rita (Salvucci) Rufo, Antonetta Salvucci, Aurora (Rufo) Salvucci, Ideale Salvucci, Henry Scagnoli, Neil Savage, Mike Sullo, Marie Tisei, Louis Totino, Michael Totino, and Linda (Salvucci) Varney.

Thanks also to the following librarians, archivists, and historical agency personnel for helping me to access relevant material: Francesco Castellano of the Dante Alighieri Society, Peter McCauley of the Revere Historical Society, Dora St. Martin of the Somerville Public Library, Paige Roberts of the Immigrant City Archives of Lowell, Aaron Schmidt of the Boston Public Library's Print Department, Douglas Southard of the Bostonian Society, and Sister Margaret Yennock of the Italian Home for Children.

—William P. Marchione, Ph.D.

One

THE LURE OF ITALY

There were few Italians in Boston before the 1880s. A mere 300 persons of Italian birth resided in the city as late as 1860. By 1880, the Italian-born element still numbered only 1,200.

Before 1890, it was far more common for Bostonians to visit Italy than for Italians to settle in Boston, for Italy served as a vital source of artistic and poetic inspiration for creative Americans. Many books and articles have been written about Italy's influence on American painting, sculpture, architecture, poetry, and music. So significant was that influence, that in 1992 the Boston Museum of Fine Arts mounted a major exhibit on the phenomenon entitled, "The Lure of Italy: American Artists and the Italian Experience, 1760–1914."

The list of Bostonians who spent time on the Italian peninsula before 1880 reads like a who's-who of the Yankee capital. It included the architect Bulfinch, who modeled so much of Boston's built environment along neo-classical lines; the great painters Copley, Allston, and Morse; the sculptors Greenough and Hosmer; such leading literary figures as Hawthorne, Longfellow, Willis, Appleton, and Lowell; the critics Parsons and Norton; the historians Prescott, Parkman, Motley, and Bancroft; the philosophers and social critics Emerson and Fuller; the great reformers Howe, Dix, and Sumner; such scholars as Ticknor, Coggswell, and Everett; and the eminent clergymen Ware and Parker. The list is both long and distinguished.

There was some movement of Italians to Boston before 1880, but it was a mere trickle, and culture played a determining role. The first Italians to settle in Boston often came at the invitation of the city's intellectual and social leadership. Early Italian settlers included such notable figures as Filippo Traetta, a Venetian conductor and composer. Traetta arrived in the late 1790s and soon after established the first American conservatory of music in Boston. Other early settlers included Luigi Ostinelli, a musician of high reputation who conducted the well-known Tremont Theater Orchestra for many years; Count Lorenzo Papanti, a Tuscan nobleman, who presided over the city's principal dancing studio; Pietro Bacchi and Pietro Monti, both professors of Romance languages at Harvard College; the Marchese Niccolo Reggio, a well-to-do merchant who acted as consular agent for several Italian states; and Father Giuseppe Finotti, a noted Catholic historian.

By 1850, a small Italian enclave was taking shape in Boston's North End, in and around North Square. This community consisted chiefly of small-scale merchants and their families who had been drawn to Boston by the opportunities in the import and export trade. Most of them hailed from the vicinity of Genoa, Italy's most dynamic commercial center.

Boston had little difficulty accommodating this small, relatively prosperous, commercially oriented, and mostly literate immigrant element. Attesting to the relatively high level of acceptance of Italians at this early stage was the selection, in 1854, of Nicholas Alessandro Apolonnio as Boston's City Registrar. The son of an Italian immigrant father, the Protestant Apolonnio held this post with distinction for nearly 40 years.

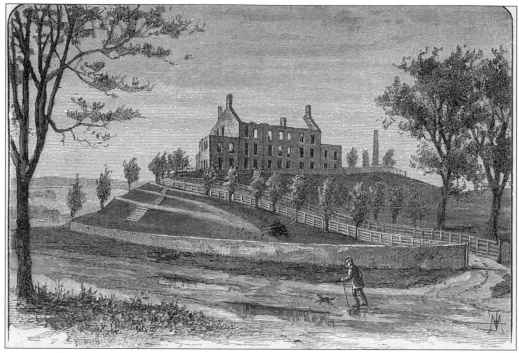

The General Court of the Massachusetts Bay Colony adopted Anti-Catholic laws as early as the 1630s. Italians and other Catholics were thus discouraged from immigrating into the Boston area in the colonial period. Only with the adoption of the Massachusetts State Constitution of 1780 were these discriminatory statutes repealed. Even then, however, anti-Catholic bias remained. In 1834, an attack by a nativist mob on the Ursuline Convent on Mount Benedict in West Charlestown (now Somerville), shown here, reduced the structure to ruins.

While relatively few Italians settled in the Boston area before the 1850s, many Bostonians traveled to Italy, especially artists and writers drawing inspiration from the peninsula's paintings, sculpture, architecture, and magnificent landscape. Among the earliest of these visitors was the great Boston architect Charles Bulfinch (1763–1844), who rebuilt much of the city along neoclassical (largely Italianate) lines.

One of Bulfinch's most magnificent buildings was the Church of the Holy Cross on Franklin Street in Boston, the city's first Catholic Cathedral. The structure was dedicated on September 29, 1803, and enlarged in 1827. Here is the cathedral as it appeared just before its demolition in 1860 to make way for the commercial expansion of downtown.

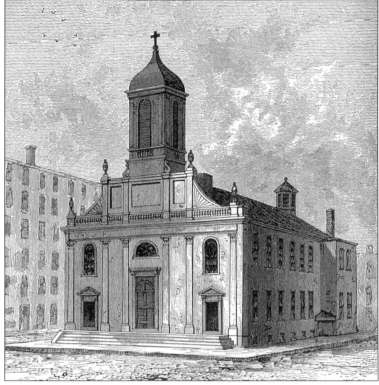

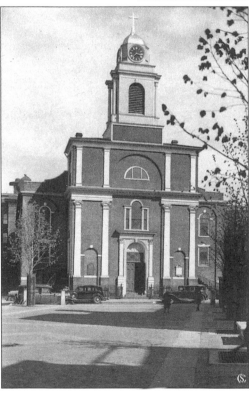

Of greater significance to the history of the Italian community in Boston was St. Stephen's Church on Hanover Street. Also designed by Bulfinch, this edifice in Boston's North End dates from 1804. In 1862, Bishop John Fitzpatrick bought the structure, which became St. Stephen's Roman Catholic Church. Predating the establishment of Boston's first Italian language Church, St. Leonard's of Port Maurice, St. Stephen's was the first church in which the Italian residents of Boston's North End worshiped. (Courtesy of Vito Aluia.)

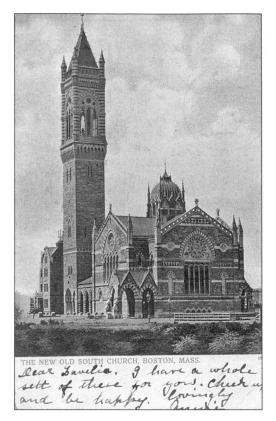

THE NEW OLD SOUTH CHURCH, BOSTON, MASS.

Dear Savelia. I have a whole sett of these for you. Check u and be happy. Lovingly

The influence of Italian architecture and design upon Boston is especially evident in Copley Square. Here we see the New Old South Church at the corner of Boylston and Dartmouth Streets. The church dates from *c.* 1874 and is a work of North Italian Gothic design by the firm of Cummings & Sears.

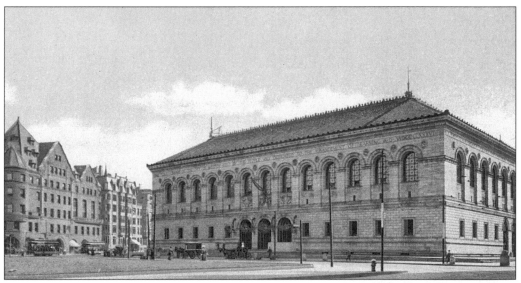

The Boston Public Library building in Copley Square, the work of the great architectural firm of McKim, Mead, & White, was completed between 1888 and 1895 and was patterned on the architecture of Renaissance Florence. Other Italianate buildings in the square included the original home of the Boston Museum of Fine Arts, which was demolished in 1912, and the magnificent Richardsonian Romanesque Trinity Church.

Another Bostonian of note, who traveled to Italy to drink of its inspiration, was the great Boston portrait painter John Singleton Copley (1738–1815.) The first significant work Copley did after his arrival in Europe was a portrait of American diplomat Ralph Izard and his wife, completed in Rome in 1775, with the Coliseum as a backdrop. This self-portrait dates from 1780.

Among the many Boston-area painters who visited Italy was Washington Allston (1779–1843), for whom Boston's Allston section is named. Allston spent the years from 1804 to 1808 on the peninsula studying the works of the great Renaissance masters. According to one biographer, these years were "perhaps the four richest years of his life." In 1818, he returned to America. This self-portrait, completed in Italy in 1805, now hangs in the Boston Museum of Fine Arts.

The great poet Henry Wadsworth Longfellow (1807–1882) made several trips to Italy during his lifetime and wrote a number of poems celebrating the beauties of the peninsula. One of his most important works was his translation into English of Dante's Divine Comedy, published in 1865.

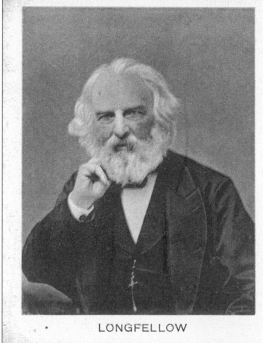

LONGFELLOW

* AMALFI *

Sweet the memory is to me
Of a land beyond the sea,
Where the waves and mountains meet,
Where, amid her mulberry-trees
Sits Amalfi in the heat,
Bathing ever her white feet
In the tideless summer seas.

Lord of vineyards and of lands
Far above the convent stands.
On its terraced walk aloof
Leans a monk with folded hands;
Placid, satisfied, serene,
Looking down upon the scene
Over wall and red-tiled roof;

On his terrace, high in air,
Nothing doth the good monk care
For such worldly themes as these:
From the garden just below
Little puffs of perfume blow,
And a sound is in his ears
Of the murmur of the bees
In the shining-chestnut trees.

From Longfellow's Poem.

This postcard, published at the turn of the 20th century, shows the elderly Longfellow along with an excerpt from his poem *Amalfi*.

Of all the Boston-area writers who visited Italy, possibly the greatest Italophile was Margaret Fuller (1810–1850.) This idealistic young woman, a highly talented writer, poet, and an early feminist, was swept into the Risorgimento movement to a far greater degree than any of her literary compatriots.

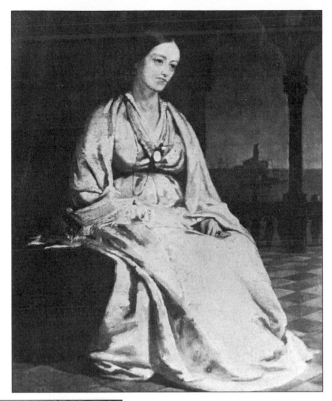

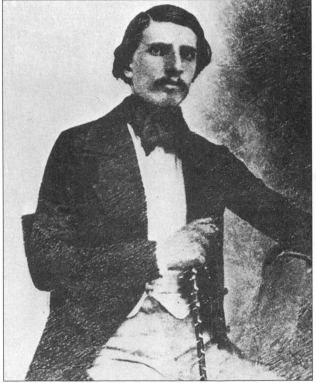

To the distress of her wealthy family and her socially correct friends, in 1848, Margaret Fuller married an impoverished Italian nobleman and patriot, the Marchese Giovanni Ossoli, pictured here. After the fall of the short-lived Roman Republic led by Mazzini and Garibaldi, in 1849, the Ossolis and their infant son fled to the United States. Tragically, all three drowned in a shipwreck off of Long Island.

Bostonians traveled to Italy to study its statuary and to seek instruction in the studios of the master sculptors of the peninsula. In 1852, 22-year-old Harriet Hosmer (1830–1908), a native of Watertown, began seven years of intensive training in the Roman studio of sculptor John Gibson.

Among the most interesting of the long list of 19th century Bostonians who were lured to Italy was Isabella Stewart Gardner (1840–1924), the widow of a leading Boston financier. Mrs. Gardner was such a great admirer of Italian art and architecture, that between 1899 and 1903 she built a Venetian-style palace on Boston's Fenway to house her superb and growing art collection.

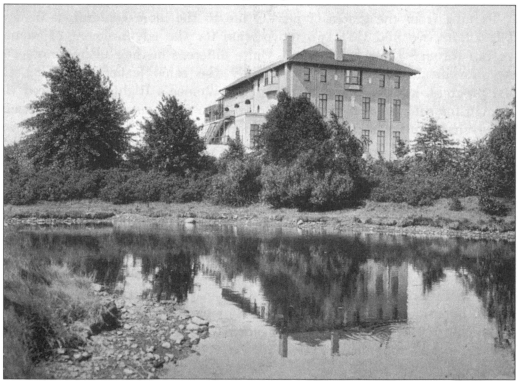

The earliest Italians to settle in Boston included men of high social rank. Count Lorenzo Papanti, a political liberal, participated in a plot to overthrow the oppressive rule of the Hapsburg Duke of Tuscany and was exiled. Settling in Boston in the 1820s, he found employment as a violinist with a local orchestra. In 1827, he established a fashionable dance studio in palatial quarters at 17 Tremont Street, which became a fixture in the social life of the city for nearly three-quarters of a century.

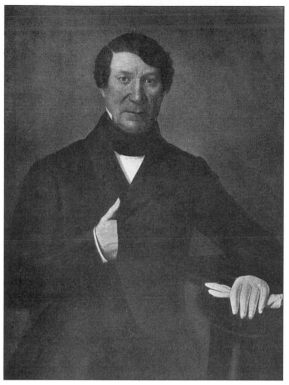

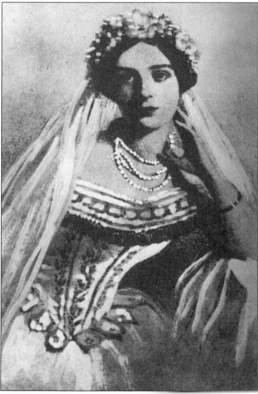

Despite its tiny population, Boston's early Italian community produced a celebrity of international reputation, the great coloratura soprano Eliza Biscaccianti. Born in Boston in 1824, she was the daughter of Luigi Ostinelli, the director of the Musical Society of Boston and a native of Como, Italy, and Sophia Henrietta Hewitt of Boston. Eliza received her musical education in Italy. "La Biscaccianti," as she was known, appeared in the great European and America opera houses of her day.

15

The Marchese Nicholas Reggio (1810–1867,) immigrated to Boston from Smyrna, Turkey, in 1832. Members of the Genoese nobility, the Reggios had settled in the Italian colony in Smyrna (now Izmir) in the 14th century, engaging in extensive maritime activities. Nicholas was sent to Boston by the Reggio firm to handle the sale of their goods locally. The Marchese Reggio was a major Boston export/import merchant. (Courtesy of Erdna [Reggio] Rogers.)

The *Smyrniote,* shown here in 1861, was one of Nicholas Reggio's ships. Reggio was also a leading lay Catholic who served at various times as Boston consul or vice consul for the governments of the Papal States, the Kingdom of Sardinia, the Kingdom of the Two Sicilies, the Kingdom of Italy (united in 1861), and Spain. When his chief business competitor, Joseph Iasagi, a Smyrniote of Greek extraction, provided a statue of Aristides the Just for the private park at the center of Beacon Hill's Louisburg Square, Reggio followed suit by providing one of Christopher Columbus. Both statues still adorn the park. (Courtesy of Erdna [Reggio] Rogers.)

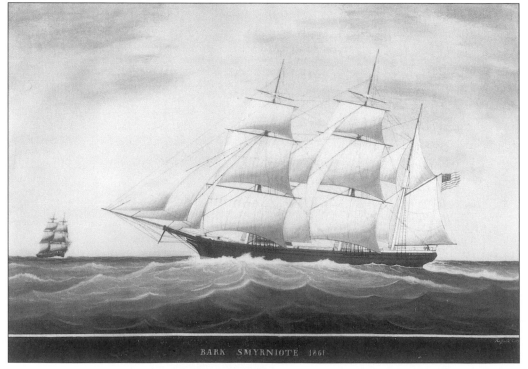

BARK SMYRNIOTE 1861

In 1844, Nicholas Reggio married Pamela Green Miller, the stepdaughter of prominent merchant and philanthropist Andrew Carney, namesake of the Carney Hospital. In the early years of their marriage, the Reggios lived either with or very near the Carneys on Summer Street. After 1864, they resided at 1 Commonwealth Avenue in Boston's prestigious Back Bay. Pictured here are, from left to right, the Reggio daughters: Mary Francis, born 1850; Josephine Elizabeth, born in 1846; and Clementine, born in 1848. (Courtesy of Erdna [Reggio] Rogers.)

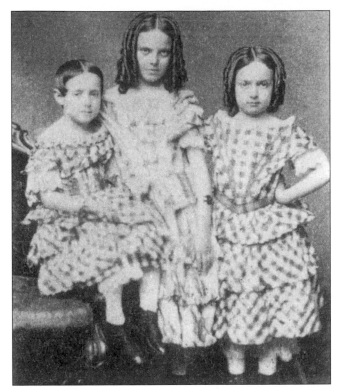

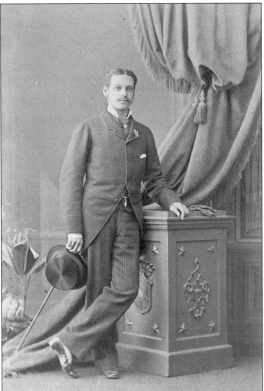

The Reggio's youngest child and only son, Andrew Carney Reggio, was born in 1853 and graduated from Harvard College. This photograph of the fashionable young man was taken in Rome, probably in the 1870s. (Courtesy of Erdna [Reggio] Rogers.)

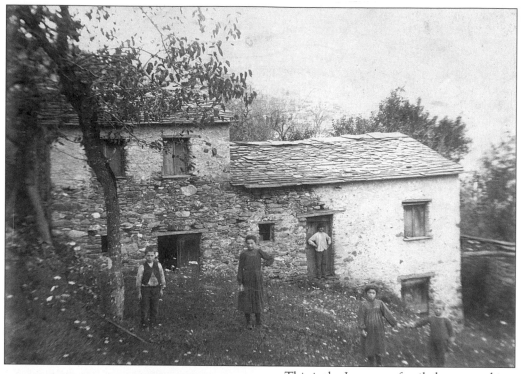

This is the Leverone family homestead in Cicagna, near Genoa, in northeastern Italy. The Leverones settled in Boston in the 1870s. Many of the earliest Italian families in the North End hailed from the Cicagna area. (Courtesy of Robert Leverone.)

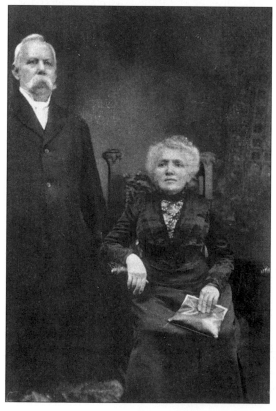

Pictured here are Giovanni Battista Carabbio and his wife, early residents of Boston's North End, on their 50th wedding anniversary celebration on Columbus Day, October 12, 1911. The Carabbios were married at St. Stephen's Church on Hanover Street in 1861 and had 12 children. (Courtesy of Vito Aluia.)

Two

THE GREAT MIGRATION

After 1890, Italians began immigrating to the United States in massive numbers. In all, some six million entered this country between 1890 and 1920.

By the 1880s, the economic and political condition in southern Italy, the so-called *Mezzogiorno*, had become intolerable for many of its people. The region had been incorporated into the northern-dominated kingdom of Italy in 1861. When southerners resisted that consolidation, government troops were sent in, a centralized (largely northern) bureaucracy was installed, and high taxes and a harsh conscription law were imposed on a people already living a hand-to-mouth existence.

These events, coupled with mounting economic hardships the people suffered after 1880, forced the massive exodus. First, the largely agricultural region lost its traditional wheat and citrus markets to the more advanced farm economies of the United States, Argentina, Australia, and Canada. Then a tariff war with neighboring France deprived Italy of its principal market for grapes. To make matters worse, in the late 19th century, southern Italy was struck by a succession of devastating physical disasters: recurrent earthquakes, volcanic eruptions, epidemics, floods, and crop failures. Moreover, these events unfolded during a period of rapid population growth, which placed an unbearable burden on the area's meager resources.

America offered Italians opportunities that were simply not available at home. The typical Italian entering the United States in this period came with the intention of finding work, accumulating money, and then returning to the bosom of his family and his native village with his savings. There was little disposition on the part of these early immigrants to settle permanently in the United States. Such temporary immigrants were called "birds of passage." This tentative approach to immigration tended, of course, to slow assimilation.

The crisis in the *Mezzogiorno* coincided with a stage in U.S. economic development in which American enterprise had the need for huge quantities of cheap labor. Labor agents, acting for American railroads and manufacturers, aggressively promoted emigration throughout southern Italy in these years. It was this need for cheap labor that explained the survival of the country's traditional policy of open immigration into the 1920s in the face of mounting native anti-immigrant sentiment.

Italian immigrants were drawn to the Boston area by a host of factors. The city was a major port of entry with its own immigration facilities. Impoverished immigrants often could not afford to travel to more distant destinations where conditions were more favorable, like California. In addition, the pre-existing Italian settlements in Boston's North End provided a valuable support network for these newcomers. But the most important factor influencing Italians to choose Boston over other destinations were the many jobs available for semi-skilled and unskilled immigrants in the construction, transportation, and manufacturing sectors of Greater Boston's economy.

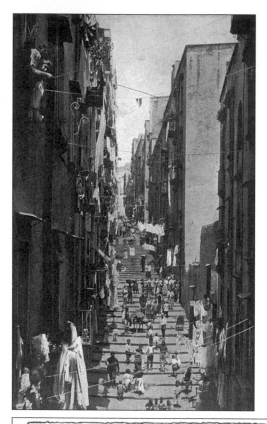

The city of Naples and its surrounding area were an important source of immigrants after 1890. In 1898, American travel writer John L. Stoddard described the crowded streets of Naples. He wrote, "Some of these alleys are but six feet wide, and seem even narrower by reason of the gloomy tenements which rise on either side to an amazing height, and only stop where poverty itself will climb no higher."

Earthquakes frequently wreaked massive destruction in the *Mezzogiorno* region, adding to the distress of its beleaguered population and encouraging emigration. John Stoddard, recounting an earthquake that devastated the beautiful island of Ischia in the Bay of Naples in 1883, wrote, "Suddenly the entire island shook convulsively. The movement lasted only fifteen seconds, but when it was over a sweet, peaceful scene of human happiness and industry had been transformed into one of agony and ruin."

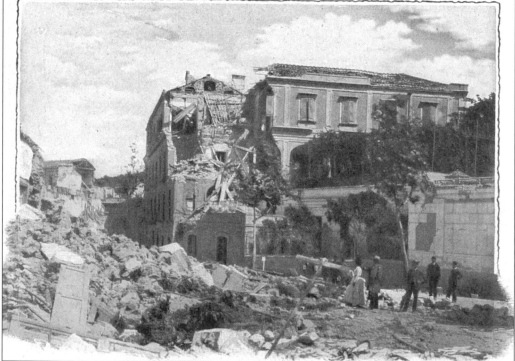

This picture appears in William Agnew Paton's 1902 volume, *Picturesque Sicily*. While artfully posed for poetic effect, the subject nonetheless conveys a sense of the grinding poverty that prevailed in the Sicilian countryside in the late 19th century. Sicily furnished about one-fourth of all Italian immigrants in the Great Migration period.

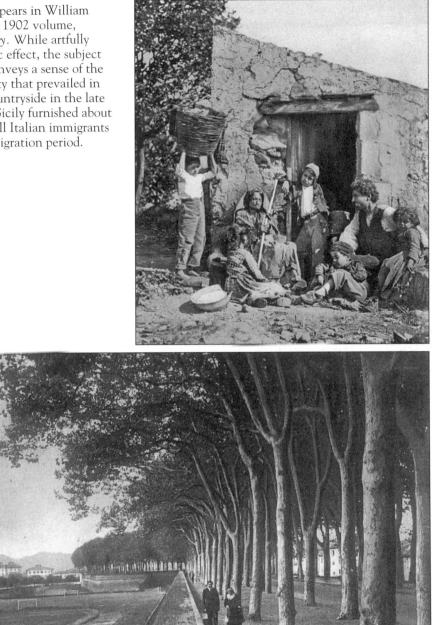

Northern Italy, which had been the primary source of immigrants in the pre-1890 period, continued to provide significant numbers in the post-1890 period, though its contribution was by then far outweighed by the migration from the south. The area around the city of Lucca, pictured here, in northern Tuscany, was a major source of immigration. (Courtesy of Laura [Pepi] Bain.)

Pietro Salvucci, a stonemason by trade, arrived in America from his native village of San Donato in 1898 and typified the "birds of passage" phenomenon. Over a period of 26 years, he traveled between Boston and his native village nine or ten times. By 1921, his eldest son Loreto had joined him in the United States, but their families remained in Italy. Only in 1924, when the U.S. government adopted strict immigration laws, did they make a permanent commitment to the United States, bringing their families to Brighton, Massachusetts.

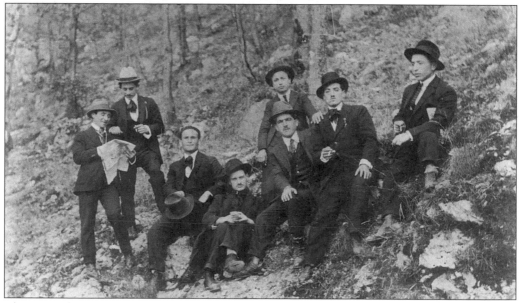

This view shows Loreto Salvucci (the hatless figure) taking leave of his friends on a hillside near San Donato just prior to the family's departure for America in 1924. Several of the men pictured here later crossed the ocean as well, including Gaetano Cugini (extreme right) and Donato Salvucci (center rear). (Courtesy of Antonetta Salvucci.)

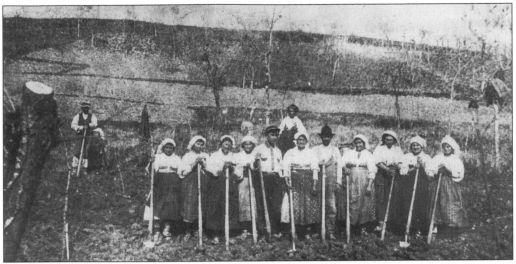

A factor encouraging emigration was the primitive character of Italian agriculture and a severe scarcity of land. Many Italian families owned no land at all. Others owned only small, widely separated parcels. Italian peasants frequently worked on the land of the gentry for wages. Here we see a gang of farm laborers, mostly female, on the outskirts of San Donato about 1890. (Courtesy of Ideale Salvucci.)

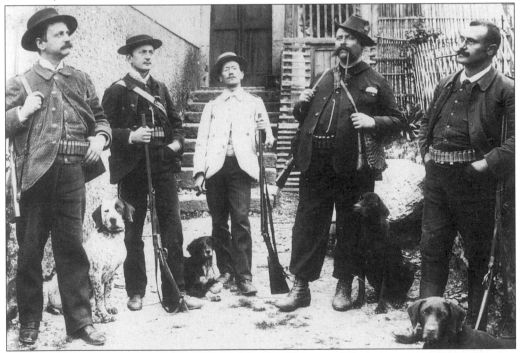

Members of the gentry of San Donato posed for this photograph before setting out on a hunting expedition in 1910. Another factor that helped generate the Great Migration was the rigid class structure that prevailed in Italy, even among the common people. Families that earned their livelihood from a trade identified themselves as *artiste* and considered themselves socially superior to the peasants, who they classified as *cafone*, or vulgar country people. (Courtesy of Ideale Salvucci.)

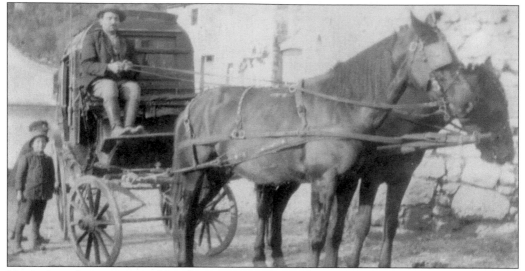

Horse-drawn conveyances like this one carried members of the Salvucci family from San Donato val di Comino to dockside in Naples in 1924, where they boarded the steamship *Christopher Columbus* that carried them to Ellis Island in New York City. The Salvuccis traveled, as was the case with most Italian immigrants of the Great Migration period, in steerage. (Courtesy of Antonetta Salvucci.)

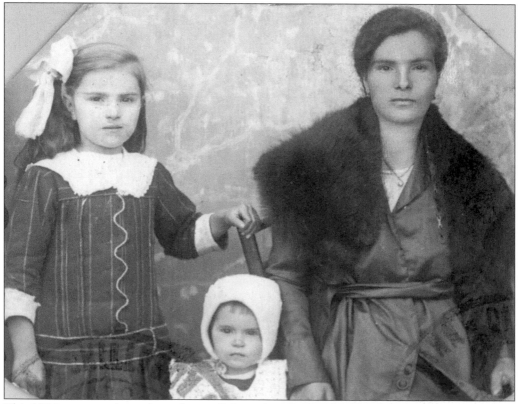

This 1924 passport photo shows Loreto Salvucci's wife, Cesidia (Sacchetti) Salvucci, and their daughters, Maria, age nine, and Antonetta, age two. (Courtesy of Antonetta Salvucci.)

In this 1924 photograph, Maria Salvucci, age nine, and her uncle (her father's youngest brother), Teodolindo Salvucci, age 10, take leave of the patriarch of the family, Carmine Salvucci, age 73. The widowed Carmine later joined his son, Pietro, in Boston, dying there in 1934. (Courtesy of Antonetta Salvucci)

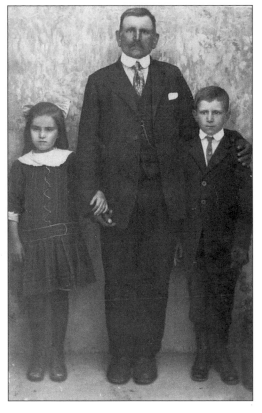

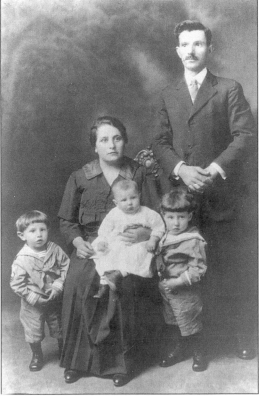

Immigration was often a two-way phenomenon, as shown in this photograph of the Sachetti family returning to San Donato in 1930. Donato Sacchetti immigrated to Boston with his wife Donata in about 1918. However, in 1930, Donato's ill health and the depressed American economy prompted the family's return to San Donato. Later, their three sons (American citizens by virtue of their birthplace) returned to the United States. (Courtesy of Antonetta Salvucci.)

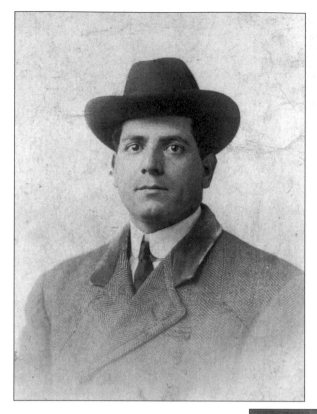

Santi Panarello immigrated to Boston from Scaletta Zanclea, Province of Messina, Sicily, at the turn of the 20th century. By 1909, Santi was a successful businessman who owned a nine-chair barbershop with his brother Francesco at 181 Court Street, Bowdoin Square, Boston. (Courtesy of Marge [Panarello] DiSciullo.)

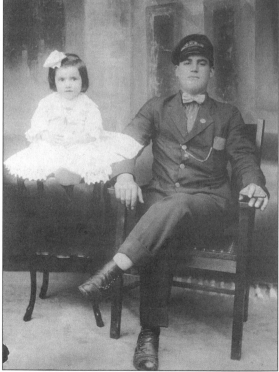

Maria Michelina Pietracatella appears here with her uncle, Rocco Iosue, in about 1912. Michelina was born in Monacilioni, Campobasso, Italy, in 1910. She immigrated to the United States with her widowed mother, Carmina Iosue Pietracatella, and her grandmother, Rosalba Iosue. This photograph was probably taken in the United States shortly after her arrival. Uncle Rocco, who had been in America for some time, was employed as a Boston Elevated Railroad conductor. (Courtesy of Marge [Panarello] DiSciullo.)

26

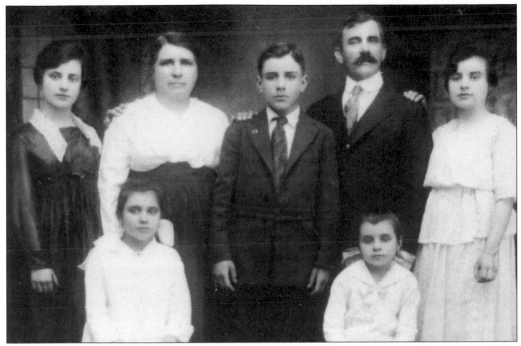

The Orlandi family arrived in Boston from Torre dell'Lago, Province of Lucca, in 1919. Pictured here, from left to right, are the following: (standing) Diva, Giuseppa, Francesco, Matteo, and Francesca; (seated) Argentina and Theresa. The father, Matteo Orlandi, was a stone mason. Their first place of residence in America was a farm in Concord, and they would later move to East Boston and Richmond Street in the North End before moving to Brighton in 1942. (Courtesy of Gloria [Tofanelli] Puccini.)

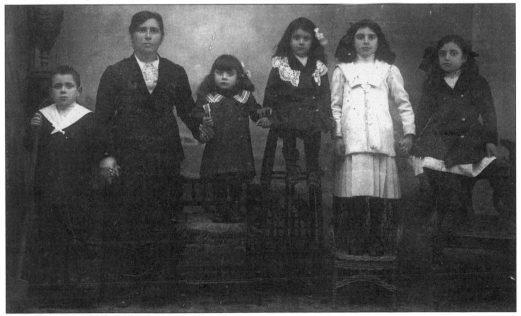

This portrait of Giuseppa Orlandi and her five children was taken in Torre dell'Lago about 1916. (Courtesy of Gloria [Tofanelli] Puccini.)

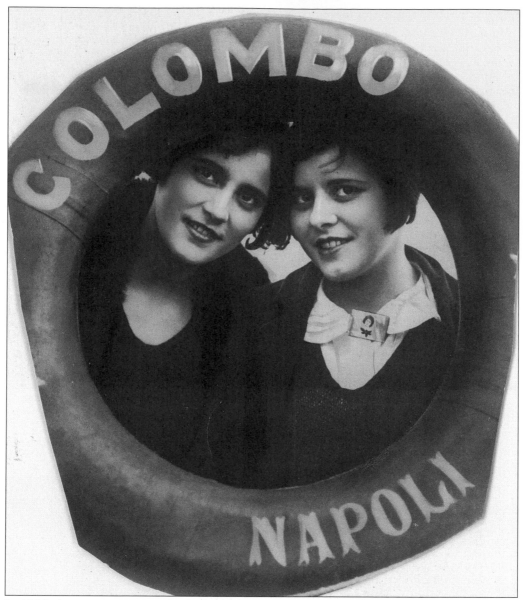

In 1926, the two youngest Orlandi children, Theresa and Argentina, ages 16 and 18, returned to Italy aboard the steamship *Colombo* to visit relatives. (Courtesy of Gloria [Tofanelli] Puccini.)

Large-scale emigration from Italy resumed after WWI and peaked in 1920, the last year of open immigration. This photograph is of Vincenzo Bonsignore in the uniform of a WWI Italian soldier, with his brother, before his emigration from Enna, Sicily. Vincenzo settled in East Cambridge in the early 1920s and opened a shoe repair shop on Cambridge Street. (Courtesy of Anthony Ricciardi.)

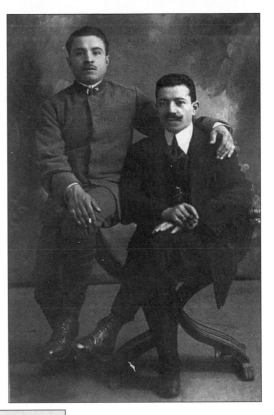

Antonio Vinti (front) appears here in a WWI Italian army photo. Vinti also immigrated to America after the war to join his brother, Antonio, a successful tailor. However, he did not remain long, returning to Naples within a few years. (Courtesy of Anna [Vinti] Edmonson.)

CONNOTATI

Statura m. 1.53

Fronte _regolare_

Occhi _castani_

Naso _giusto_

Bocca _giusta_

Capelli _castani_

Barba

Baffi

Colorito _roseo_

Corporatura _regolare_

Segni particolari

Firma del titolare _Ciampa Raffaele_

Visto per l'autenticazione della fotografia e della firma.

Il (1)

Passaporto rilasciato

dalla R _Questura_ di _Avellino_

N° del Passaporto _357_

O 3 FONDO PER L'EMIGRAZIONE

Raffaele Ciampa, age 23, arrived in Boston from Montefalcione, near Naples, which was a major source of immigrants to the Boston area. He arrived in 1922 aboard the steamship *Arabic*, landing at the East Boston Immigrant Station. Here we see his passport. (Courtesy of Elisa Ciampa.)

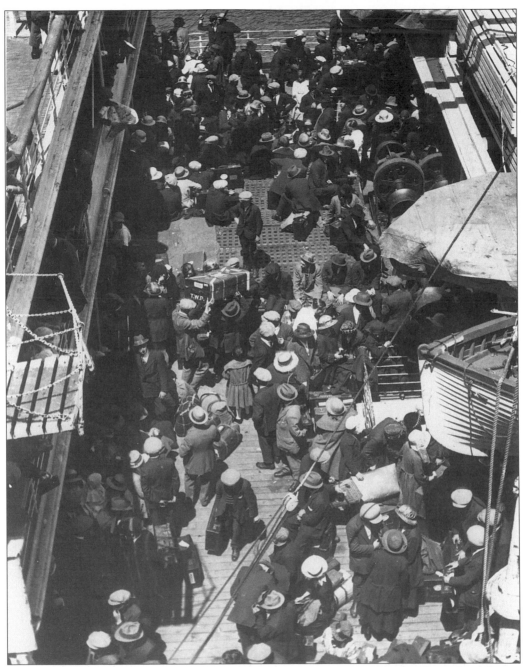

In a photograph labeled, "A portion of the July Quota," we see immigrants from the Adriatic (probably from the port of Trieste) landing at the East Boston Immigration Station on July 23, 1923. This was just before the rigid new immigration laws went into effect that cut Italian immigration by more than 95 percent and put an end to the Great Migration. (Courtesy of the Boston Public Library.)

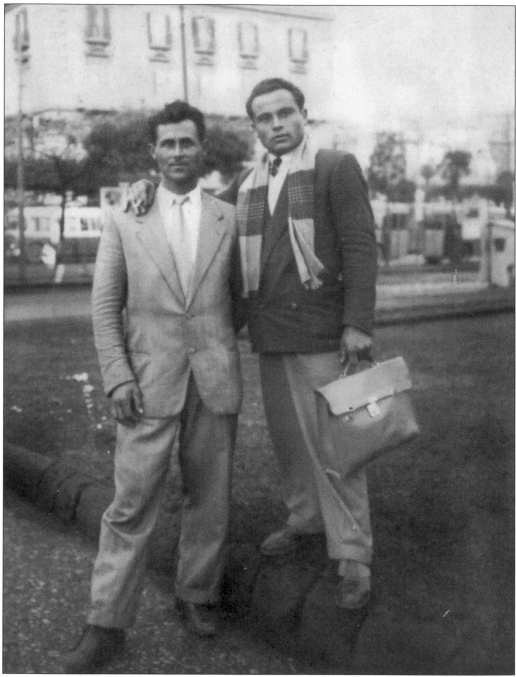

One of the legacies of the highly restrictive system imposed in the early 1920s was a change in direction of Italian immigration toward nations that were more welcoming. Brothers Nicola and Domenico Caniglia, from Filetto, Province of Chieti, in the Abruzzi, are seen here in December 1951, taking leave of one another near the docks in Naples from which Domenico was about to sail for Argentina. In 1966, Domenico and his family left Argentina for Boston. The Caniglias currently live in Watertown, where many Italians of Filettese background reside. (Courtesy of Joe Caniglia.)

Three
PREJUDICE AND PRIDE

Italian immigrants arrived at a time when industrial capitalism was rising, and therefore, they became pawns in an intensifying struggle between capital and labor. In addition, nativism and racism among Americans were on the rise in the United States. The immigrant restriction movement took much of its impetus from the theories of racial superiority that were coming out of many academic and cultural bastions in the late 19th and early 20th centuries.

The conditions Italian immigrants faced in Boston were especially difficult. Until the mid-19th century, Boston had been a city made up predominantly of non-immigrants. Then, after 1846, its ethnic and religious complexion changed dramatically with the arrival of vast numbers of Irish Catholic immigrants who were driven from their homeland by the great potato famine.

The Irish were obliged to wage a long and difficult battle for recognition and advancement. In time, Boston became the only major city in the nation where they comprised a majority of the population. By the 1920s, Irish Americans had established themselves in Boston's politics, public employment, labor movement, and Catholic Church. The older Protestant element, on the other hand, retained control of the Massachusetts state government, as well as the city's primary business, financial, cultural, and philanthropic institutions. The new immigrant elements, the city's Italians, Jews, Slavs, Lithuanians, Greeks, and Armenians, were effectively excluded from both spheres.

Italians entered Boston suffering from a whole range of social and economic disabilities. They were the poorest immigrant group to arrive in the Hub since the potato-famine Irish. They were also predominately unskilled and mostly illiterate. In addition, they spoke a strange language with many mutually incomprehensible regional dialects. Moreover, they were burdened by a negative image. The stereotypical view of Italians that had been taking shape in the American mind for years held them to be shiftless, superstitious, clannish, hot-tempered, and prone to criminal activities such as extortion, racketeering, and even assassination.

Italians also tended to self-segregate by place of origin. Neapolitans preferred to live with fellow Neapolitans, Sicilians with Sicilians, Calabrians with Calabrians. Therefore, the early Italian immigrants were isolated from Italians of different backgrounds as well as other elements of Boston's population.

The Italian experience in Boston generated great frustration. Opportunities for advancement in politics and public employment were severely limited. Career opportunities in trade and commerce were virtually non-existent. Italian entrepreneurs, new to the country, were unable to obtain credit from locally dominated financial institutions, forcing them to rely upon unstable immigrant banks, such as the Banca Commerciale Italiana, which collapsed in the Great Depression.

Between 1920 and 1945, Boston's Italians were also confronted with a succession of crises that shook the community to its very foundations. These included the closing off of

immigration between 1920 and 1924, injustices associated with the Sacco-Vanzetti trial and executions, and the internal political divisions generated by the rise to power in 1922 of the Fascist dictator Benito Mussolini. Perhaps most traumatic, though, was the tragic state of war that broke out between the United States and Italy in 1941, pitting the nation of their origin against their adopted homeland.

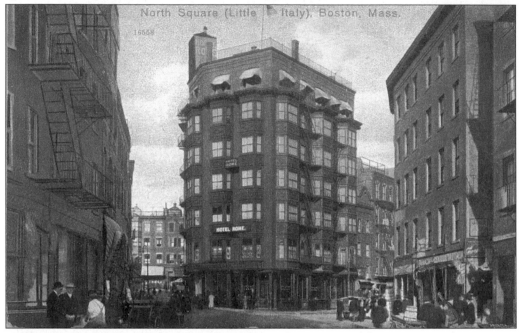

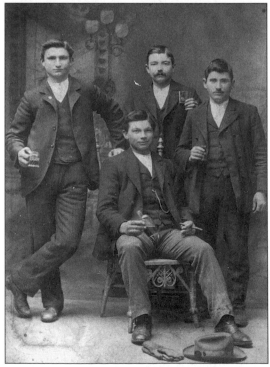

Some sense of the congestion that prevailed in Boston's "Little Italy" is gained from this picture of North Square in Boston's North End during the first decade of the 20th century. The tall building at the center of this picture was the Hotel Rome. (Courtesy of Vito Aluia.)

Many Italians were drawn to America by the ample job opportunities in construction and public works projects. Here, four young men, Cesidio Perruzza, a friend surnamed Tramontozzi, and Pasquale and Cesidio Baccari, all from the town of San Donato, are employed building the giant Wachusett Dam and Reservoir in Clinton, Massachusetts, c. 1900. When completed in 1906, the Wachusett Dam was the largest reservoir in the world. While Cesidio Perruzza eventually settled in Brooklyn, New York, his married daughters Marie Rufo and Adeline Rufo moved to Brighton in 1942. (Courtesy of Adeline [Perruza] Rufo.)

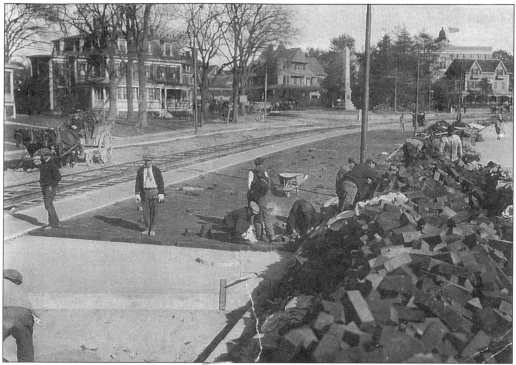

An Italian labor crew widens Humphrey Street on the Swampscott waterfront on October 27, 1914. Some of the earliest Italians to reach the suburban communities around Boston came as members of construction gangs. (Photograph by Stuart Ellis, courtesy of Sylvia Curato.)

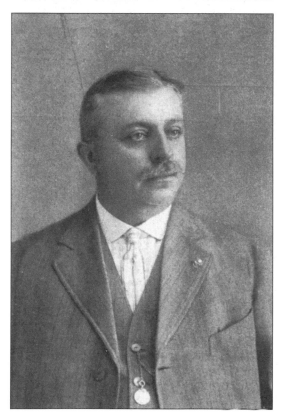

Italians made scant political progress in the early years, even in their principal ethnic enclave, the North End. The first Italian elected to the Massachusetts House of Representatives was Andrew Badaracco, pictured here. A successful North End undertaker and realtor, Badaracco was elected in 1902 with the support of Martin Lomasney's West End–based Hendrick's Club political machine. "The Mahatma," as the powerful Irish boss was known, held the North End in a political thralldom well into this century.

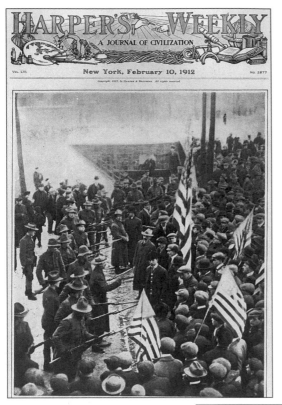

HARPER'S WEEKLY
A JOURNAL OF CIVILIZATION

Vol. LVI. New York, February 10, 1912 No. 2877

Copyright, 1912, by Harper & Brothers. All rights reserved.

Italians provided much of the leadership in one of the noblest struggles in the history of organized labor, the Lawrence Textile Strike. In 1912, the American Woolen Company decided to cut wages. Its employees responded by walking out of the mills. Management used every dirty trick it could think of to defeat the strikers. The workers persevered nonetheless, and the company was obliged finally to give way to their modest demands. (Courtesy of the Collection of Immigrant City Archives, Lawrence, Massachusetts.)

A disproportionately high number of Italian-Americans saw service in the U.S. army during WWI. Among Italian Americans who made the ultimate sacrifice was Cesare A. Marchi, the first Somerville Italian American to lose his life in the war. Somerville's Marchi playground, which lies at the intersection of Moreland Street and Edgar Avenue, was dedicated to his memory in June 1935. (Courtesy of Marie [Marchi] Bonello.)

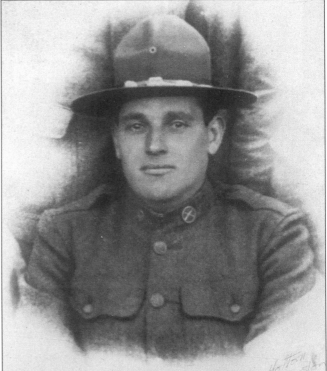

Cesare Marchi's family sent him this photograph, taken in the Ten Hills Section of Somerville, while he was stationed in Verona, Italy, during WWI. It was addressed "With Best Wishes, from your brothers." Several of the photos in the extensive Marchi family collection show members posed around natural objects such as trees and ledge outcroppings. Brother Gianetto, an accomplished photographer, may have been responsible for these artful poses. (Courtesy of Marie [Marchi] Bonello.)

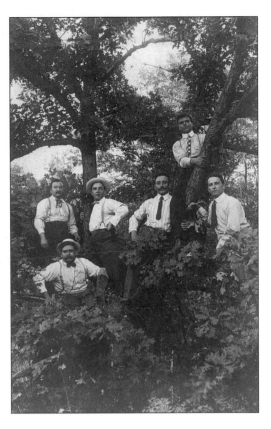

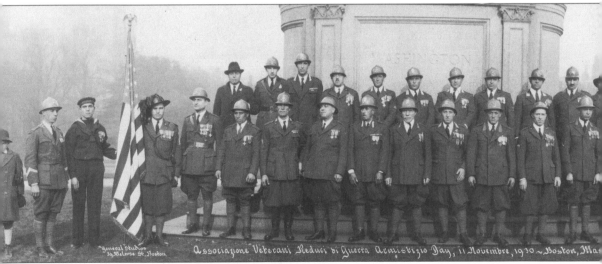

Many immigrants who had served in the Italian army during WWI sought to maintain contact with other Italian veterans. This gathering in the Boston Public Garden of the "Associazione Veterani Pieduci di Guerra," took place on Armistice Day, November 11, 1930. In the front row (second from left) stands active member Raffaele Ciampa of West Roxbury. Ciampa carefully preserved a large collection of memorabilia from the war years, including his uniform, medals, and citations, which his family still possesses. (Courtesy of Elisa Ciampa.)

Among Raffaele Ciampa's most treasured possessions was this autographed portrait of Italy's King Victor Emmanuel III. In October 1929, the monarch sent this portrait to the *valorosi cammerati* (valorous comrades) of the Boston Italian WWI Veterans Association. (Courtesy of Elisa Ciampa.)

Just after WWI, the Charles Ponzi Scandal erupted in Boston. Ponzi, an Italian immigrant, persuaded thousands of people to invest in his Security Exchange Company, promising enormous short-term profits. Seen here in his State Street office in August 1920, Ponzi made good on his promises for a time, winning plaudits for his financial skill from the state's politicians, journalists, and even Wall Street investors. Inevitably, however, his pyramid scheme collapsed, and many lost their life savings. (Courtesy of the Boston Public Library.)

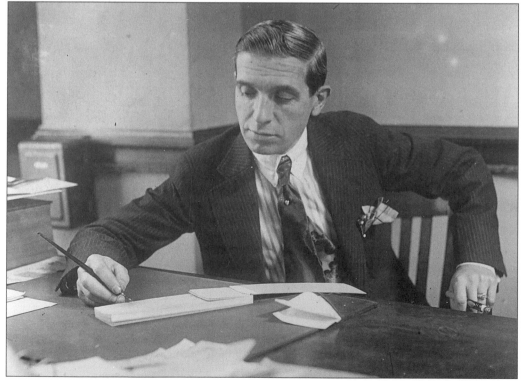

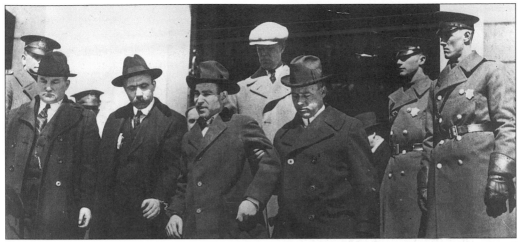

No single episode of the 1920s was more demoralizing for Italians than the Sacco-Vanzetti trial and executions. Nicola Sacco and Bartolomeo Vanzetti, Italian immigrants and philosophical anarchists, were arrested for an armed robbery and murder that had taken place in South Braintree, Massachusetts, on April 15, 1920, at the height of the so-called "Red Scare." In this photograph are Sacco and Vanzetti outside of the Dedham Courthouse, where they were tried and found guilty of murder in 1920. (Courtesy of the Boston Public Library.)

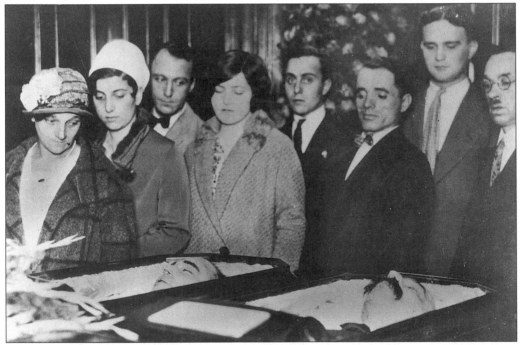

Determined to bring in a guilty verdict against these dangerous foreigners, Judge Webster Thayer refused to allow the testimony of Italian witnesses that placed the accused elsewhere at the time of the crime. Despite substantial evidence of discrimination, Governor Alvan T. Fuller refused to commute their death sentences. Sacco and Vanzetti were executed on August 23, 1927. Their bodies were on display here at the Langone Funeral parlor in Boston's North End. Over 100,000 mourners attended this wake, reputedly the largest ever held in Boston. (Courtesy of the Boston Public Library.)

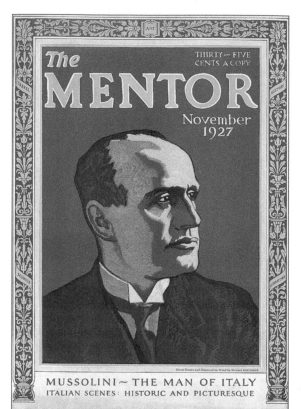

THE MENTOR

THIRTY—FIVE
CENTS A COPY

November
1927

MUSSOLINI ~ THE MAN OF ITALY
ITALIAN SCENES: HISTORIC AND PICTURESQUE

The frustrations Italians experienced after WWI helps explain the popularity Fascist dictator Benito Mussolini enjoyed in the Italian immigrant community in this country. However, it should be emphasized that, before 1935, Mussolini was also highly regarded by many non-Italians in the United States. Indicative of the esteem in which Americans held Mussolini before his alliance with Hitler is this November 1927 celebratory issue of the American magazine *The Mentor*, published on the fifth anniversary of his assuming power.

A gathering of Italian WWI ex-combatants was held in Cambridge on November 17, 1937. The caption of this photograph notes that the veterans were commemorating three historic dates: November 4, 1918 (the Austro-Hungarian armistice); November 11, 1918 (the German armistice); and October 28, 1922 (Mussolini's "March on Rome," which led to the Fascist takeover of Italy). (Courtesy of Anthony Ricciardi.)

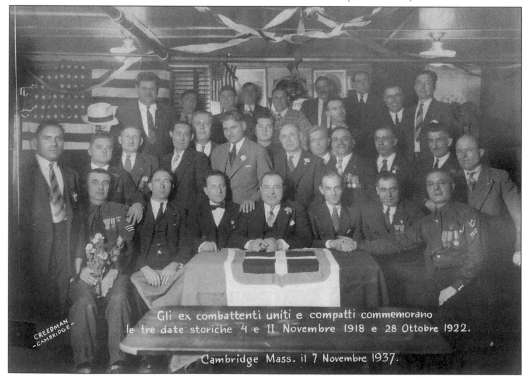

Gli ex combattenti uniti e compatti commemorano
le tre date storiche 4 e 11 Novembre 1918 e 28 Ottobre 1922.

Cambridge Mass. il 7 Novembre 1937.

Not all Italians approved of Mussolini. Italian opposition to Fascism came primarily from two sources, those desiring a return to representative forms of government, many of whom had been driven into exile in America (called *fourusciti*), and those on the far left politically. During the Spanish Civil War (1935–1939), many anti-Fascist Italian Americans joined the so-called Lincoln Brigade, an American force that fought against Mussolini's army on the Spanish peninsula. One of these was Giulio Fontini, pictured here, who in November 1937 sent his Boston friends greetings from Spain in the name of "democracy and world peace." (Courtesy of Antonetta Salvucci.)

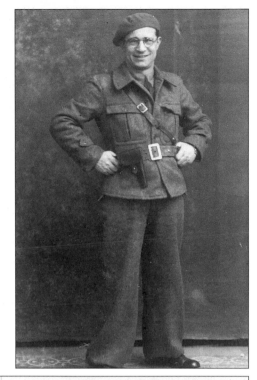

With the outbreak of war between the United States and Italy in December 1941, an alien enemy registration system was instituted. These papers were issued to Luigi Mazzulli of South Boston, who had lived in Boston almost 30 years but had never become a citizen. Fortunately, only ten months after the war began, the U.S. government concluded that they represented no threat and exempted Italian aliens from the wartime restrictions imposed on other enemy alien nationalities. (Courtesy of Terri Mazzulli.)

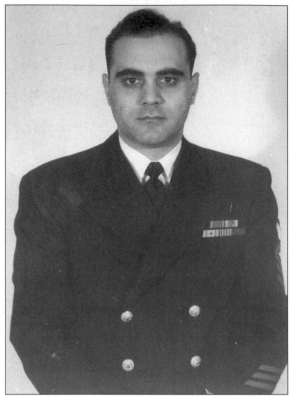

In Italian immigrant experience, the males of the family often came to America first. Sometimes they returned permanently, and sometimes they brought their families over to join them later. In the case of the Morano family of Monterosso Calabro, Province of Catanzaro, older brother Rocco came in 1902, settling in Boston, where he married and raised a family. Almost 20 years later, in 1921, his younger brother Antonio also emigrated, leaving his wife and family behind in Italy, never to return. During World War II, Rocco's son, Michael (pictured above), served in the U.S. Navy, while his first cousin, Antonio's son, Nazzareno (below), served in the Italian Navy. Only after WWII did the cousins meet for the first time, when Michael visited Italy while on a naval assignment. (Courtesy of Kathryn [Morano] Farrell.)

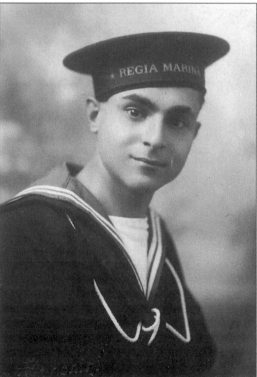

Rocco Marzilli of Newton is seated in front of an American flag just before his departure for service in WWII. (Courtesy of Anna [Tocci] Marzilli and Rocco Marzilli.)

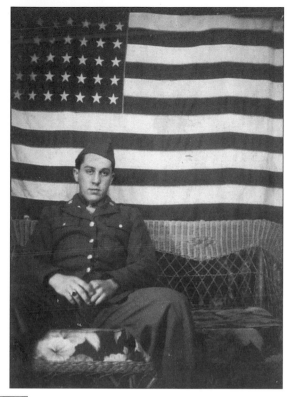

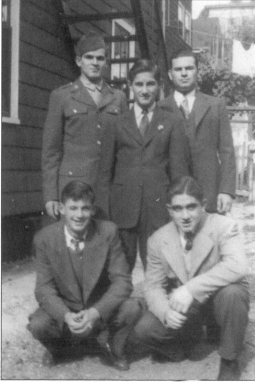

Gaetano (Guy) Cuggino was photographed in the yard of his family's home on Shannon Street in Brighton just before departing to serve in the U.S. Army during WWII. With him are his brothers Larry, Nazzareno (Ned), Joe, and Tony. (Courtesy of Mary [Antonellis] Cuggino.)

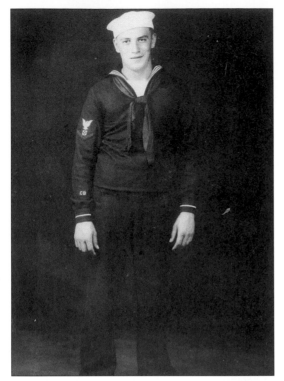

Joseph Pagliasso of the West End served in the seabees during WWII. He was stationed in Guam, Saipan, and Tarawa in the Pacific Theater, where he contracted malaria. (Courtesy of Marge [Panarello] DiSciullo.)

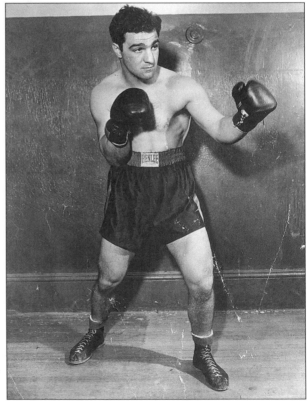

In a climate of severely limited opportunities, many Italian Americans sought advancement through competitive sports. Here we see Rocky Marciano (born Rocco Marchegiano) of Brockton, who in 1952 won the world heavyweight boxing championship, retiring undefeated in 1956. Rocky's father, Perrino Marchegiano, had emigrated from Chieti, a fishing village in the Abruzzi, before WWI. He settled in Brockton and worked in the shoe industry. The fighter's mother, Pasquelina Picchiutto, came to America from San Bartolomeo, near Naples, in 1918.

Four

THE FIRST

NEIGHBORHOOD

The North and West Ends of Boston became the primary ethnic enclave for Italian immigrants. This downtown district, with its Italian stores, Italian language churches, and the services of Italian doctors, lawyers, labor agents, travel agents, and other professionals, provided the immigrants with a relatively familiar, friendly, and manageable environment. By 1920, the Italian population of these two contiguous downtown neighborhoods approached 50,000.

Employment opportunities were plentiful in the downtown. Jobs abounded in nearby factories, on the waterfront, in area railroad yards and truck depots, with the construction crews that local *padrones* or labor agents organized, and in the adjacent market district where Italians found employment as vendors of meat, fruit, and vegetables. While jobs were plentiful, the work tended to be low paying as well as physically exhausting.

The downtown district also provided critically important patronage for aspiring Italian entrepreneurs. Some of Boston's most successful Italian businessmen got their start there as produce merchants, bakers, undertakers, pharmacists, liquor dealers, tailors, and restaurant proprietors. Perhaps the best example of a major business success was the Prince Macaroni Company, founded by three Italian immigrants on the North End's Prince Street in the early 1900s.

The living conditions in the core neighborhood, the North End, were, however, quite harsh. Most of the housing stock consisted of old three- to four-story walk-up apartments that lacked private baths or central heating. The most densely populated neighborhood in Boston, the North End, also had the city's highest mortality rate. Later, as Italians made a permanent commitment to this country, North End housing conditions improved appreciably. By 1902, 19 percent of the neighborhood's residential structures were owned by Italians. By 1922, over half were in Italian hands.

The North End's organizational infrastructure expanded dramatically in the early years with the establishment of such institutions as Sacred Heart Church (1888), St. John's School (1903), St. Anthony's School (1920), as well as a plethora of mutual benefit and religious societies. It was chiefly North End residents who were responsible for founding the Home for Italian Children in 1919, the leading Italian philanthropic institution in the city.

Despite their growing numbers, Italians made scant political progress in the North End. Italian immigrants were slow to seek citizenship, so their political influence was, for many years, not commensurate with their numbers.

The development of the Italian community in the neighboring West End came a bit later, as

the older district filled. The two communities formed a single ethnic entity, with West End Italians relying on the same stores, services, and social institutions as North End residents. Italians were never a numerical majority in the West End. They comprised only about 40 percent of the district's total population. The balance consisting mostly of Jews, Irish, Poles, and Lithuanians. Whereas the West End suffered a tragic demolition in the mid-1960s as part of Boston's early urban renewal initiative, the North End survives virtually intact and is to this day still referred to as Boston's "Little Italy."

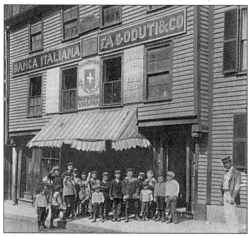

This is a famous postcard view of the Paul Revere House in North Square, at the heart of Boston's North End. It shows that historic property, the oldest building in Boston, as it looked just before its restoration in 1908. Notice the signage. The businesses operating out of the Paul Revere house at the turn of the 20th century included the Banca Italiana, one of several immigrant banks that were providing critical services in the burgeoning immigrant community. (Courtesy of Vito Aluia.)

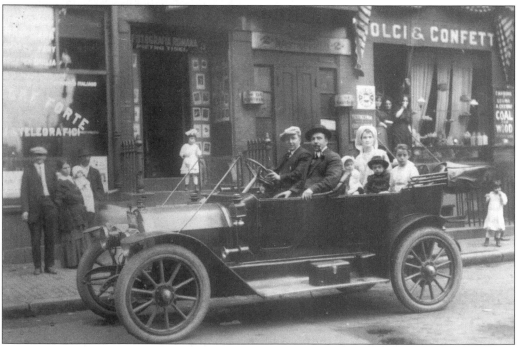

This 1914 photograph was taken in front of the studio of photographer Pietro Tisei in North Square (center left), at the heart of the downtown Italian enclave. Tisei immigrated to Boston from Tivoli, near Rome, before 1900 and settled in Somerville. To the left of the Tisei studio stood a telegraphic office and, to the right, an Italian pastry shop. In the open car in the foreground sit Mr. Buoncuore, Pietro's wife, Maria, and their children, Caroline, Francis, and Ralph. (Courtesy of Marie Tisei.)

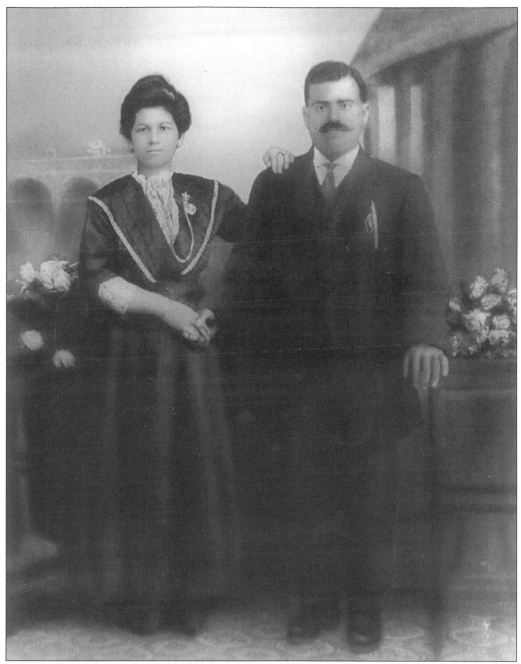

Filomena and Raimondo Bono lived in Boston's North End in the early years of the century. Both had emigrated from Sciacca, Sicily, and they were married in New York City's Elizabeth Street Italian colony, where they lived before moving to Boston. Immigrants from Sciacca, a major center of the Italian fishing industry, tended to enter that trade here. Raimondo Bono was a charter member of the Madonna del Soccorso di Sciacca Society. He and his sons berthed their fishing vessels at Boston's T Wharf, the headquarters of Boston's Italian fishing fleet. Three generations of Bonos engaged in the local fishing industry. (Courtesy of Jimmy [Bono] Geany.)

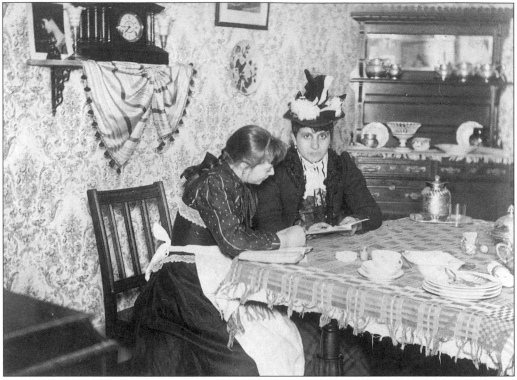

A young Italian girl is taught to read in her home, in 1902, by a North End Mission worker. The North End Mission maintained its headquarters at 201 North Street in the heart of the Italian district. Founded in 1865, the agency operated an industrial school for girls, a nursery and kindergarten school for children, a home for unwed mothers, and a summer home for children. (Courtesy of the Boston Public Library.)

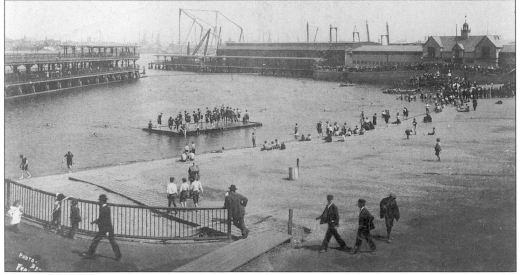

Open spaces were at a premium in the crowded North End. The largest park in the area was the North End Park on the waterfront. This 1908 photograph also shows the Boston Navy Yard in the background. (Courtesy of the Boston Public Library.)

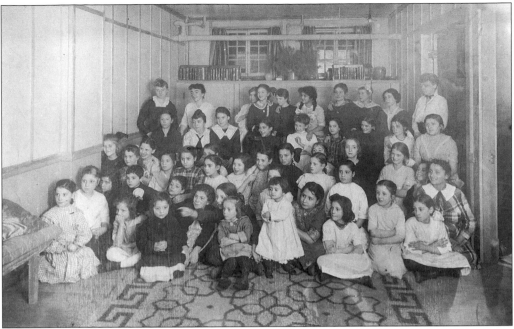

The local branches of the Boston Public Library also furnished a broad range of educational and social services in the downtown Italian enclave. Here, a large group of mostly Italian children listens to a Victrola in the Club Room of the North End Branch Library about 1920. (Courtesy of the Boston Public Library.)

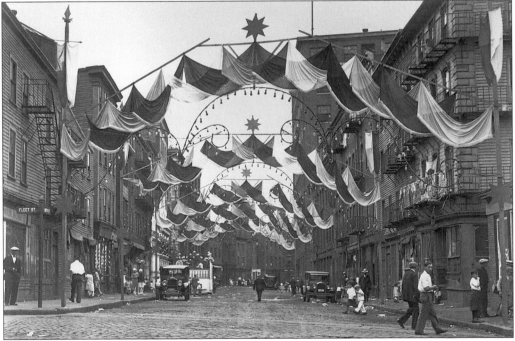

North Street in Boston's North End was decorated for All Saint's Day, June 23, 1929. Parades, pageants, and Saints Day observations have long played an important part in the social and religious life of Boston's Italian community. (Courtesy of the Boston Public Library.)

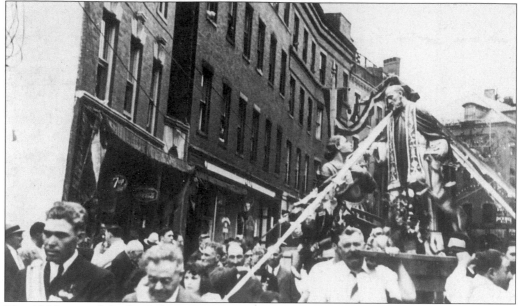

This 1938 view of the St. Cologero procession on North Street in the North End marks the last time the statue was paraded through the streets of the district. (Courtesy of Jimmy [Bono] Geany.)

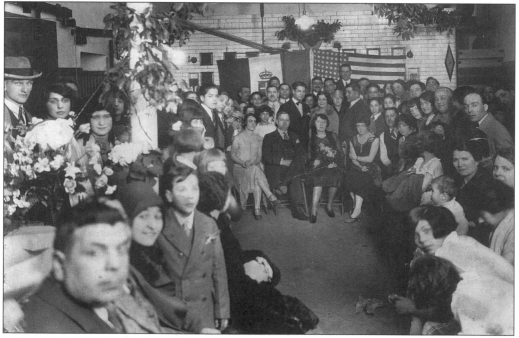

Italian Americans gathered at Cassaro's Bakery on West Margin Street in the West End in 1937. (The owner of the bakery, Louis Cassaro, is in on the right wearing the vest.) The exact nature of the gathering is uncertain. However, the juxtaposition of the Italian and American flags symbolizes the dilemma that then confronted the Italian community as the relationship between the nation of their origin and their adopted nation steadily deteriorated. (Courtesy of Anthony Ricciardi.)

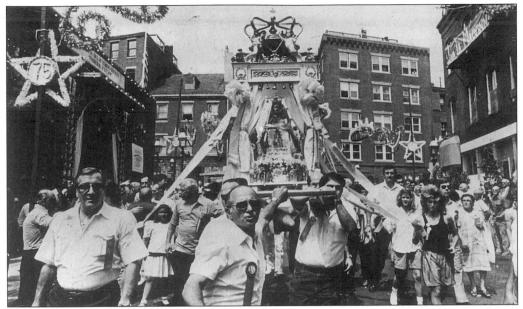

The statue of the Madonna del Soccorso, patron saint of the fishing fleet, is being carried from its permanent home at the Fishermen's Club at 11 Lewis Street in Boston's North End through the streets of the neighborhood in 1986. This ceremony is held every third Sunday in August. Fourteen men are required to transport the heavy plaster and wooden statue. In the foreground, steering the Madonna through the streets, is Captain Raymond Bono. (A Boston Herald photograph, courtesy of Jimmy [Bono] Geany.)

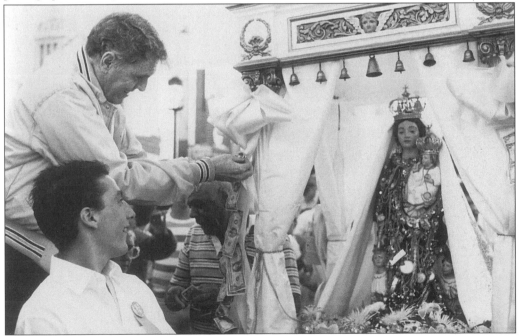

In 1986, then Boston Mayor Raymond Flynn pinned money on the statue of the Madonna del Soccorso during the Saints Day Procession. The Madonna del Soccorso Society was founded in 1910. (Courtesy of Jimmy [Bono] Geany.)

This ancient pushcart, labeled "G. Spinale," parked somewhere in the West End, symbolizes the importance of the marketplace and outdoor food vending business to the economic life of Boston's downtown Italian enclave. (Courtesy of Joseph LoPiccolo.)

A zeppole vendor plies the streets of Boston's North and West Ends. Zeppoles, lightly fried pieces of sweet dough dusted with sugar, remain a great popular favorite. Here, zeppoles are being cooked on the streets of Little Italy in the 1950s. (Courtesy of Joseph LoPiccolo.)

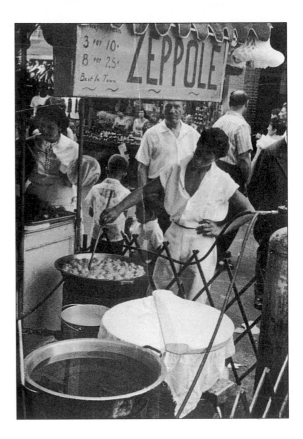

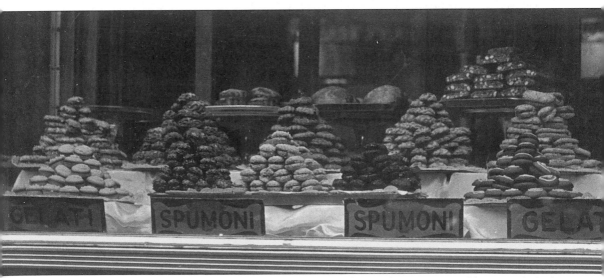

A bakery window, somewhere in the West End, offers gelati and spumoni in addition to baked goods, about 1950. (Courtesy of Joseph LoPiccolo.)

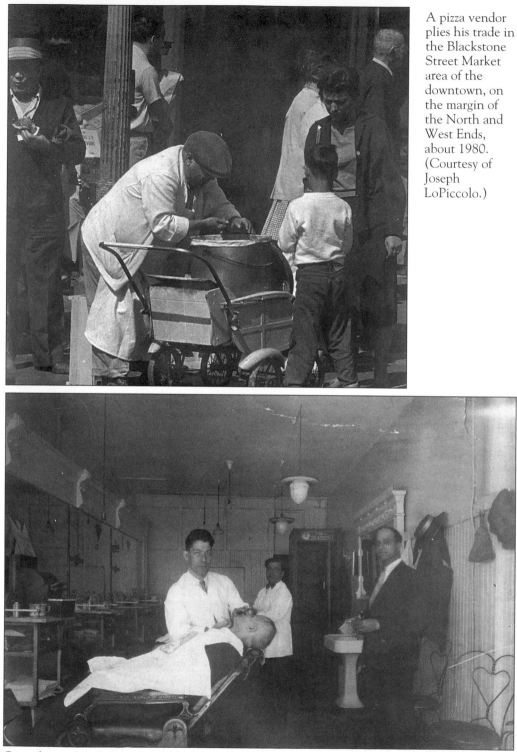

A pizza vendor plies his trade in the Blackstone Street Market area of the downtown, on the margin of the North and West Ends, about 1980. (Courtesy of Joseph LoPiccolo.)

One of countless Italian-owned barbershops in the downtown, this one was in the West End in the 1920s. (Courtesy of Joseph LoPiccolo.)

West Ender Liborio LoBlundo was photographed outside his home at 75 Brighton Street. (Courtesy of Joseph LoPiccolo.)

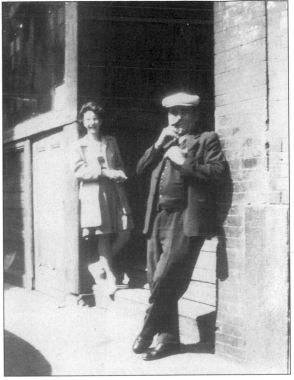

As this photo indicates, Italians had assumed a dominant position in the North End by mid-century. In this 1951 photo of a kindergarten class at St. John's Parochial School on Moon Street, every child, without exception, was of Italian ancestry. Vito Aluia, who stands ninth from the left in the back row, provided the photo.

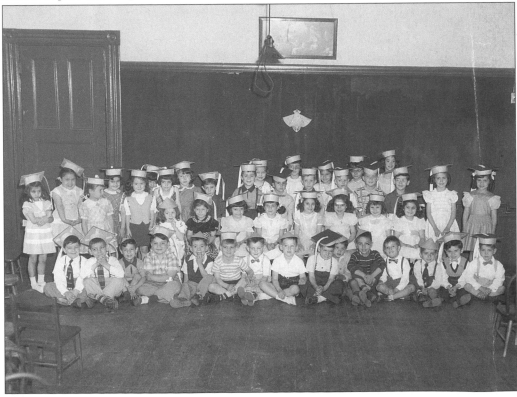

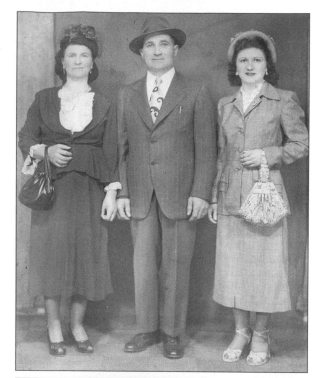

Because of the immigrant restriction legislation enacted in the early 1920s, comparatively few Italians entered Boston between 1924 and 1945. In the post-WWII era, however, a second, albeit much smaller, wave of Italian immigrants began arriving. Francesco Ventresca, a mason by trade, his wife, and their daughter, Adelia, immigrated to the North End from Sulmona, in the Abruzzi, in 1947. (Courtesy of Francine and Cleto Crognale.)

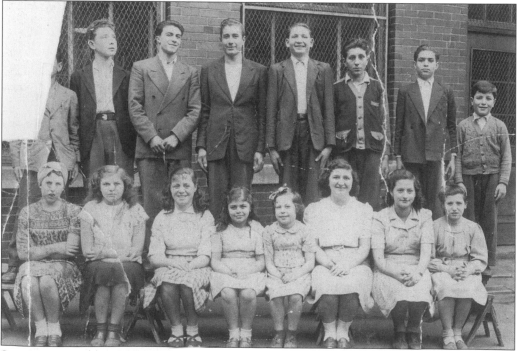

Since 17-year-old Adelia Ventresca spoke only Italian, she enrolled in an English language class at the North End's Michelangelo School shortly after her arrival. Adelia (seated third from the right) is pictured here with other English language students at the Michelangelo School in 1947. (Courtesy of Francine and Cleto Crognale.)

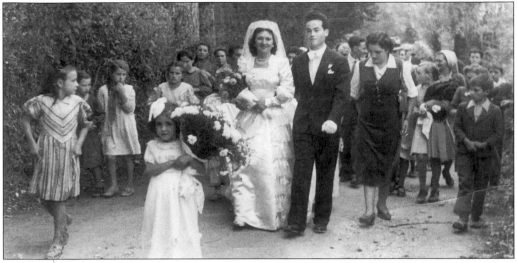

In 1949, Adelia Ventresca returned to Sulmona to marry Cleto Crognale, who was a mason by trade, like her father. This photograph shows the newly married couple returning home on foot following their wedding ceremony. The Crognales remained in Italy until 1952, while Cleto completed his service in the Italian army. They then moved to Boston and settled on Clark Street in the North End. In 1966, the Crognales moved to Newton, where the family still resides. (Courtesy of Francine and Cleto Crognale.)

THE UNITED STATES OF AMERICA

ORIGINAL
TO BE GIVEN TO
THE PERSON NATURALIZED

No. 7070179

CERTIFICATE OF NATURALIZATION

Petition No. 311191

Personal description of holder as of date of naturalization: Date of birth August 19, 1929 sex female complexion medium color of eyes brown color of hair brown height 5 feet 3 inches weight 128 pounds; visible distinctive marks none Marital status married former nationality Italian
I certify that the description above given is true, and that the photograph affixed hereto is a likeness of me.

Adelia Crognale
(Complete and true signature of holder)

UNITED STATES OF AMERICA } ss:
DISTRICT OF MASSACHUSETTS
Be it known, that at a term of the—————District————Court of
——————The United States——————
held pursuant to law at——————Boston——————
on April 28th 1952 the Court having found that
ADELIA CROGNALE
then residing at 34 Clark Street, Boston,
intends to reside permanently in the United States (when so required by the Naturalization Laws of the United States), had in all other respects complied with the applicable provisions of such naturalization laws, and was entitled to be admitted to citizenship, thereupon ordered that such person be and (s)he was admitted as a citizen of the United States of America.
In testimony whereof the seal of the court is hereunto affixed this 28th
day of April in the year of our Lord nineteen hundred and
fifty-two and of our Independence the one hundred and
seventy-sixth

JOHN A. CANAVAN
Clerk of the—U. S. District——Court.
By ————————Deputy Clerk.

It is a violation of the U.S. Code (and punishable as such) to copy, print, photograph, or otherwise illegally use this certificate.

DEPARTMENT OF JUSTICE

This 1952 Naturalization Certificate conferred the status of United States citizen on Adelia (Ventresca) Crognale. (Courtesy of Francine and Cleto Crognale.)

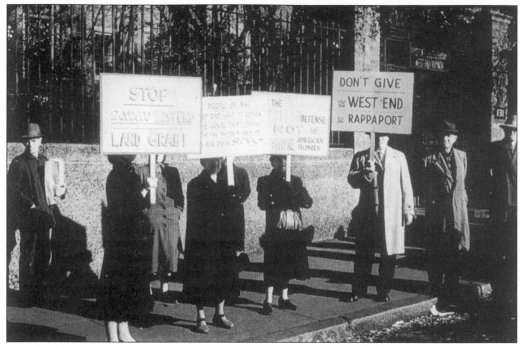

West Enders gather outside the Old West Church on Cambridge Street to protest against the proposed West End urban renewal project, spearheaded by developer Jerome Rappaport. The clearing away of this largely Italian neighborhood to make way for modern, mostly institutional structures has been widely criticized as both unnecessary and shortsighted. (Courtesy of Joseph LoPiccolo.)

The roofs of houses in the crowded downtown districts were often utilized for gardening and outdoor entertaining. This is Mary Alterio of East Boston on the roof of her house at 63 Frankfort Street in East Boston's Italian enclave about 1934. Mary's immigrant parents emigrated from the vicinity of Avellino. (Courtesy of Elisa Ciampa.)

Five

SUBURBAN ENCLAVES

While the North and West Ends contained the largest single concentration of Italians, by the 1920s, a majority was actually living in suburban locations.

The second-largest concentration of Italians in the Boston area was in East Boston, centered in the Jeffries Point area at the far southern end of the island. A second East Boston settlement, smaller but more upscale, was situated at the northern end of the island, in Orient Heights.

The industrialized towns of the lower Mystic River Valley, especially Revere, Somerville, Medford, Chelsea, Everett, and Malden, also attracted very large numbers of Italians. When seeking improved living accommodations, the denizens of the congested downtown district most often moved to these neighborhoods. By 1915, Italians constituted a majority of the population of the city of Revere. It was there that Andrew Casassa scored the group's first major political successes, becoming the pioneer Italian-American state senator in 1922 and then the first mayor of a Massachusett's municipality in 1930.

Italians with fishing experience (many of them Sicilians) settled in such North Shore locales as Salem, Swampscott, Marblehead, and Gloucester. However, Italians were also drawn into the great industrial centers north of Boston, like Lawrence, Fitchburg, Leominster, and Haverhill, by the many job opportunities available there in the textile industry.

Employment opportunities in public works drew Italians into the western suburbs. By 1920, major enclaves had arisen in Brighton, Newton, Watertown, Waltham, Framingham, Clinton, and Milford. As a center of the marble quarrying and ceramics industries, Milford attracted a highly skilled element.

Italians were also drawn to Worcester, the state's second largest municipality, by the job opportunities available there in construction, transportation, and manufacturing. Most settled on the city's east side. Some founded successful small businesses, catering at first to an exclusively immigrant clientele but gradually winning broader patronage. In time, a thriving Italian community developed in that industrial city, served by its own Italian-language Catholic church, Our Lady of St. Carmel, a parish school, and even a Baptist mission under an Italian minister.

Italians also settled in the communities on the city's southern periphery but in somewhat smaller numbers than elsewhere. The largest enclaves developed in the South End, Roxbury, Dorchester, Jamaica Plain, and Hyde Park.

The largest Italian communities south of the city were to be found further out, in the industrial cities of Quincy, Brockton, and Plymouth. Quincy's famous granite quarries employed large numbers of Italian stone cutters. Italians also found employment in the city's shipyards, factories, and railroad yards. Brockton's shoe factories provided jobs for many Italians. They were also drawn to the historic city of Plymouth, some 50 miles south of Boston, by job opportunities in the local cordage mills and fishing industry.

While the great majority of Italian immigrants settled in commercial and industrial cities and towns, a significant number ventured into agriculture, producing fruit and vegetables for the urban markets of the region.

Giselda Marchi stands in front of her family home at 45 Derby Street, Somerville, about 1915. The Marchis immigrated to Boston from the town of Rosina, Province of Lucca, via Scotland (where they lived from 1904 to 1909). The adult males of the family preceded the women and children in traditional fashion. Arriving in the North End in 1909, they sent for their widowed mother, younger brothers, and sister. The Marchis soon moved from the congested downtown to suburban Somerville. (Courtesy of Marie [Marchi] Bonello.)

One of the great attractions of the suburbs was the opportunity to plant a garden, since Italians were known to be great gardeners. Here, Eddie Bonello, a leading Boston chef, the husband of Marie (Marchi) Bonello, with an unidentified friend, is photographed in the garden of 45 Derby Street, Somerville, about 1960. (Courtesy of Marie [Marchi] Bonello.)

Antonio Giordano, a Chelsea storekeeper, is seen cultivating the vegetable garden behind his home in Revere about 1940. Note the grape arbor in the background. With him are Gloria Barbera and Mr. Calucci. (Courtesy of Marge [Panarello] DiSciullo.)

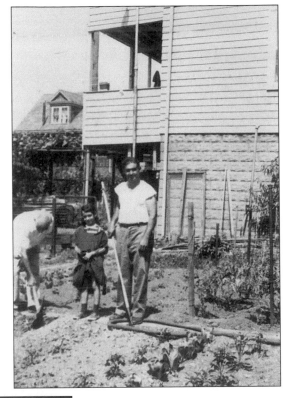

Italians also love good food. Antonio Giordano is seen here preparing dinner in the kitchen of his Revere home in the 1940s. (Courtesy of Marge [Panarello] DiSciulo.)

Marge Panarello sits on the hood of her father Gaetano Panarello's car, outside Antonio Giordano's variety store at 98 Winnisimmet Street, Chelsea. This was in the heart of Chelsea's Italian enclave, about 1945. (Courtesy of Marge [Panarello] DiSciullo.)

Gloria Giordano, daughter of Antonio Giordano and a member of the Shurtleff School Drum & Bugle Corps, is seen here in uniform on Winnisimmet Street, Chelsea, in the 1940s. (Courtesy of Marge [Panarello] DiSciullo.)

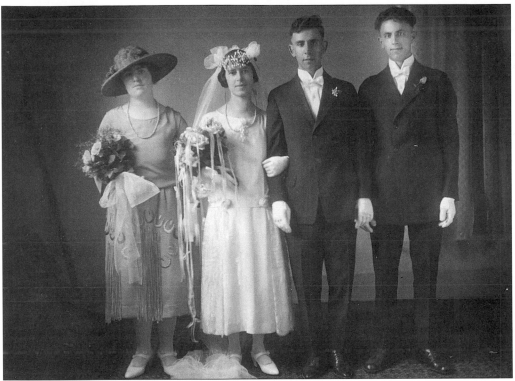

Italians were drawn to the North Shore by the opportunities in the local fishing industry. The Burgarella family, who were of Sicilian background, moved to Gloucester at an early date. Here, in 1922, Joseph Burgarella, the owner of a fishing boat, married Mary Alves, who was of Portuguese ancestry. Intermarriage among Catholic ethnic groups was already high by the 1920s. The Burgarellas were married in Our Lady of Good Voyage Church, which served Gloucester's Portuguese community. (Courtesy of Jean [Burgarella] Anjoorian.)

Gloucester's relatively rural character also attracted Italian immigrants. Here we see two of the Burgarella children in front of their Webster Street home in the late 1920s. The building in the background was an early A&P grocery store. (Courtesy of Jean [Burgarella] Anjoorian.)

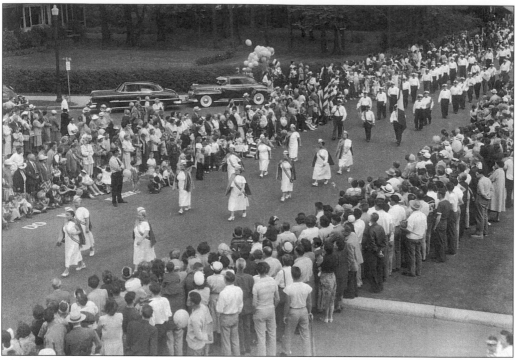

Suburban Italians, like their North End counterparts, established a variety of social and philanthropic societies. Here we see the Societa San Giovanni Mutual Aid and Social Club participating in Swampscott's Centennial Parade in 1952. (Courtesy of Sylvia Curato.)

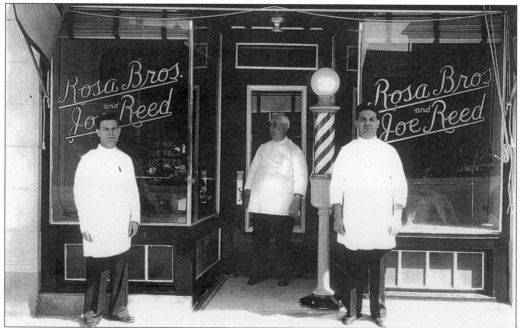

By 1930, more than half of the barbers listed in the Boston City Directory were Italians. Italian barbers were also numerous in the suburbs. This 1937 photo is of Swampscott's Rosa Brothers and Joe Reed Barber Shop, an inter-ethnic partnership. (Courtesy of Sylvia Curato.)

Suburban Medford, with its open spaces, excellent schools, and first-rate public services, represented a step up for the denizens of the downtown Italian enclave. Filomena Bono, with her grandsons, John (Bono) Geany and Jimmy Rago are photographed here on the front porch of her Lambert Street, Medford home in 1951. The Bonos had moved to Medford, as did many inner city Italians, shortly after WWII. (Courtesy of Jimmy [Bono] Geany.)

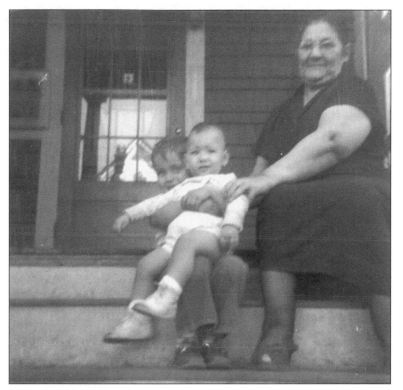

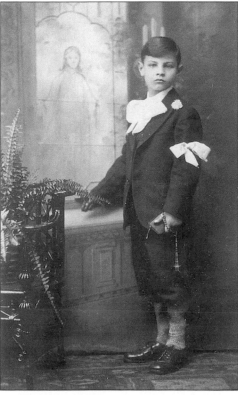

This is Salvatore Bonsignore of East Cambridge at the time of his First Communion about 1930. His father, Vincenzo, operated a shoe repair business at 525 Cambridge Street. Italians also moved into Cambridge in large numbers. A stone's throw from Boston's North and West Ends, East Cambridge offered its residents many conveniences. (Courtesy of Anthony Ricciardi.)

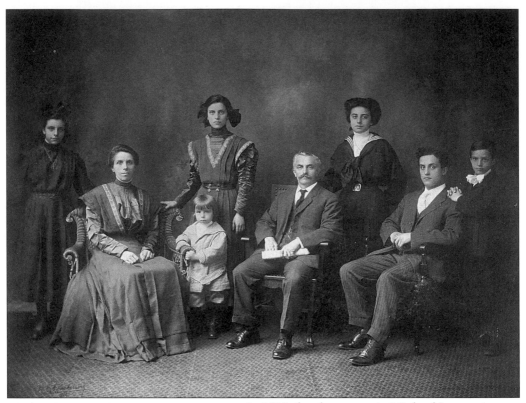

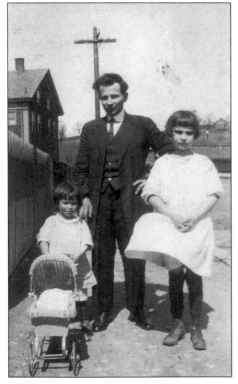

In 1913, ferryboat captain Michael Leverone moved his growing family to a handsome house at 668 Washington Street in one of Brighton's better neighborhoods. Michael's ten-year-old son, Ernest, remembered how impressed he had been with the family's new suburban home. "I was now to live in the open spaces," he recounted, "leaving the apartment in the heart of the city where I had been born." Pictured here are, from left to right, Cecilia, Justina, Rose, Louis, Michael, Louise, Joseph, and Ernest. (Courtesy of Robert Leverone.)

Italians generally lived in the older sections of suburban communities in the early years, where cheap housing was available. Recently arrived immigrants Antonetta and Maria Salvucci are shown here outside their first American home at 11 rear Snow Street, Brighton, in 1925, with a doll carriage that their uncle, Pasquale Sacchetti, had just presented to Antonetta. The principal Italian enclave in Brighton was situated just east of Brighton Center along Winship, Shepard, Shannon, Snow, and Union Streets. (Courtesy of Antonetta Salvucci.)

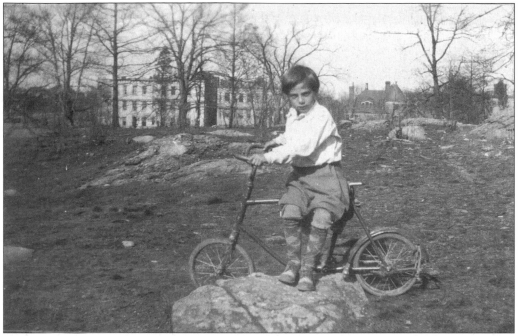

Whether rich or poor, residents of the suburbs had readier access to open spaces than did inner city residents. Seven-year-old Ideale Salvucci is photographed on the grounds of the Chestnut Hill Reservoir, near Cleveland Circle, in 1931. With him is a makeshift bicycle that his father, Loreto, built for him from discarded parts. (Courtesy of Antonetta Salvucci.)

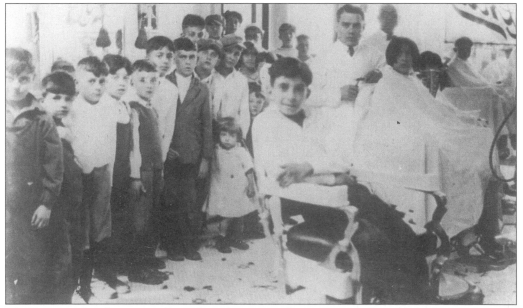

Children are lined up on a Saturday afternoon, about 1925, to have their hair cut at the Etna Barbershop on Washington Street in Brighton Center. This barbershop, which still exists, is one of the oldest surviving businesses in that commercial district. In the barber's chairs are Al Cellucci (left) and Mary Antonellis (right), age nine. (Courtesy of Mary [Antonellis] Cuggino.)

Nunziato Antonellis, a talented athlete, is seen here in football gear practicing at Rogers Park, Brighton, about 1930. (Courtesy of Mary [Antonellis] Cuggino.)

Newlyweds Alessandro and Eugenia (Stefani) Pepi emigrated, in 1908, from Piegato, Province of Lucca, in north central Italy and settled in Worcester County. They were drawn to Worcester County by the job opportunities in its factories and lived in the towns of Franklin, Milbury, and Oxford. In 1920, they moved to Plantation Street, Worcester, where they raised a family of two sons and three daughters. This is the Pepi residence on Plantation Street, which is still owned by descendants of Alessandro and Eugenia. (Courtesy of Laura [Pepi] Bain.)

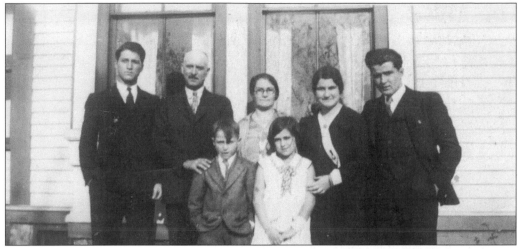

Alessandro and Eugenia Pepi are seen here with their five children outside their Plantation Street, Worcester home, about 1933. Pictured are, from left to right, as follows: Reinato, Alessandro, Roberto, Eugenia, Rita, Amelia, and Eugenio. (Courtesy of Laura Pepi Bain.)

Gaetano Panarello is dressed in as a Native American holding an American flag in this 1917 photograph, taken the year that the United States entered WWI. Italian Americans were eager to demonstrate their commitment to the cause. Gaetano was the son of Santi Panarello, who owned a large barbershop on Court Street in the downtown. The Panarellos were residents of suburban Jamaica Plain in 1917. (Courtesy of Marge [Panarello] DiSciullo.)

This photograph of Michael Vicari on horseback was taken on St. Peter's Street in Jamaica Plain, in the 1940s. (Courtesy of Joseph LoPiccolo.)

Some Boston area Italians engaged in farming. Giuseppe Mazzola, a Quincy stonecutter, purchased a chicken farm in Taunton in the 1930s after developing tuberculosis. Giuseppe's cousins, Loreta Di Bona and Cesidia Salvucci (left), are seen here with Giuseppe's wife, Amalia, at the Taunton farm in the 1960s. (Courtesy of Antonetta Salvucci.)

Six

LA FAMIGLIA

The family was the most important social unit in Italian immigrant society. Family, even more than village of origin, was the focal point of day-to-day life in the Italian enclave. While Italian society was patriarchal in structure and governance, in practice Italian mothers, who presided over the household, also wielded great influence. Italian families of the first generation tended to be rather large, often containing ten or more children.

The Italian family was also caught up in a culture of work. No obligation was greater in the eyes of immigrant parents than that of each child to contribute to the economic well being of the household as soon as he or she was capable of doing so. Many of these families, of course, were living in conditions of the direst poverty.

First generation Italian parents frequently disapproved of higher education for their children. Long-term schooling, they reasoned, meant a sacrifice of critical household income, while the young person's exposure to American values (with its greater emphasis on individualism) threatened to undermine both parental authority and family obligations.

Intergenerational tensions were an important facet of life for these families. Frustrated second generation Italians often blamed traditional values, the so-called *via vecchia* (the old way), for their failure to win more rapid acceptance and material progress. However, for the great majority of Italian Americans, accommodation to the American way moved forward inexorably, carrying along in its wake even many members of the older generation.

One of the most impressive facets of Italian family life was the assistance America-based families furnished the relatives they left behind in Italy. Not only helping them to reach America, Italian Americans also furnished their newly arrived relatives with shelter and assistance upon their arrival. Such aid was of far greater practical value to these newcomers than the paltry assistance provided by public and private social service agencies.

While most Italian immigrant households consisted of parents and children only, Italian family members tended to live in a clustered arrangement, with married sons and daughters often residing quite near (sometimes adjacent) to their parents and brothers and sisters. Thus, relatives spent much time in one another's company. Of all the groups that came to America in the late 19th and early 20th centuries, Italians were to prove the least susceptible to dispersion.

No room in the Italian household was more important than the kitchen. The Italian immigrant introduced a cuisine of incredible variety to this country, which greatly enriched American eating habits. The somewhat higher income that immigrants earned here allowed them to expand their daily fare. Italians also grew their own fruit and vegetables (often using the roofs of their tenements in the crowded downtown), made their own tomato sauces, and produced potent table wine to supplement their meals.

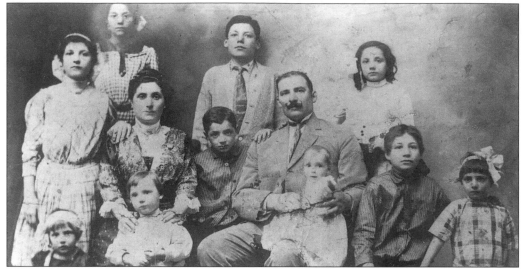

Giuseppe Sordillo, here with his family in a 1915 photograph, was a native of Montefalcione, in Avellino Province. Sordillo settled in the North End in 1899. He was a prominent North End merchant who owned and operated a seed store that the Italian community, with its many gardeners, widely patronized. Joe Sordillo crossed the Atlantic countless times to make seed purchases and was responsible for importing many new varieties of plants and vegetables into this country. (Courtesy of Elvira [Sordillo] DeAngelis.)

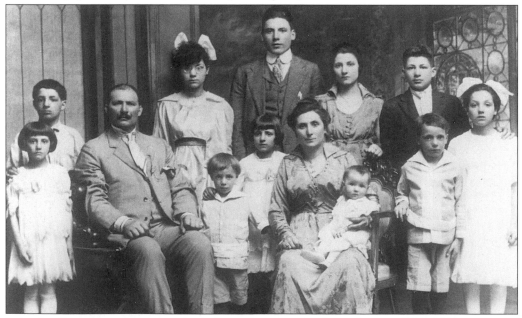

Large families were common in the Italian community in the early years. This 1918 portrait of Giuseppe (Joe) and Consiglia Sordillo, and their eleven children, was taken while they were living on North Street in Boston's North End. The children are, from left to right, as follows: (front) Mary, Americo, Angelina, Albert, Elvira, Amos, Lena, Helen (in her mother's arms), and Amodeo; (rear) Anthony and Anita. The Sordillo seed store was located first on North Street and later on Cross, Bartlett, Hanover, and Endicott Streets. (Courtesy of Elvira [Sordillo] DeAngelis.)

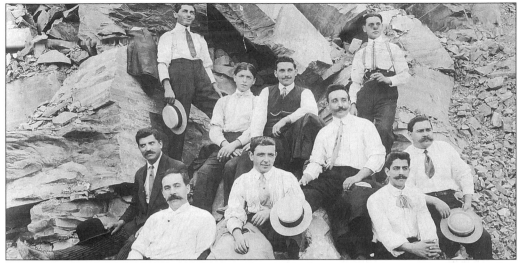

Four of the five Marchi brothers appear in this 1915 photograph, taken at Ten Hills in East Somerville. Caesar is the third from the left seated, with his hat on his knee, Battista is seated to the right of Caesar, Eugenio is seated at the extreme right, and Gianneto is the one standing farthest to the right. Battista, the eldest, owned and operated the Florence Restaurant in Downtown Boston. Cesare was later killed in WWI, and Somerville's Marchi Park was named in his honor. A fifth brother, Peter Marchi, does not appear in this photo. (Courtesy of Marie [Marchi] Bonello.)

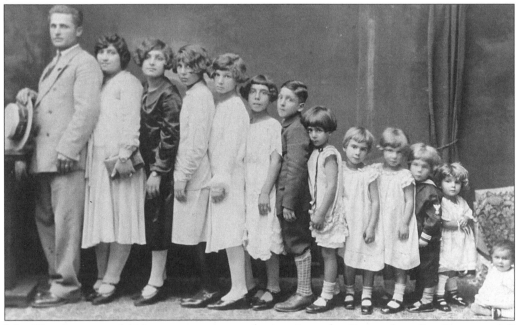

John Tocci, a successful Newton contractor, who immigrated to Boston from San Donato val di Comino around 1910, is shown here in 1927 with his pregnant wife Virginia (Di Gregorio) Tocci, and their ten children, arranged by age. The children, from left to right, are as follows: Geraldine, Francis, Germania, Antoinette, Angelo, Laura, Anna and Lucy (twins), Valentino (in a sailor's suit), Concetta, and Jean (the baby on the floor). The last of their eleven children, Esther, was born a few months later. (Courtesy of James Cummings.)

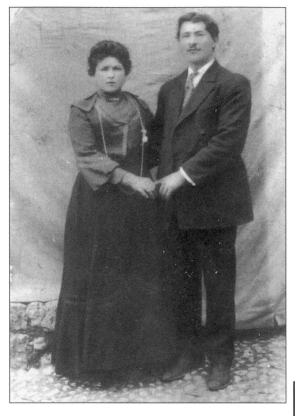

Donato Antonellis and Cesidia Pellegrini were married in San Donato val di Comino in 1904, when Cesidia was only 16 years old. Her husband preceded her to America, a common practice among Italian immigrants, and he finally sent for her seven year later, in 1911. A successful general contractor, Donato Antonellis and his family resided in Brighton. (Courtesy of Mary [Antonellis] Cuggino.)

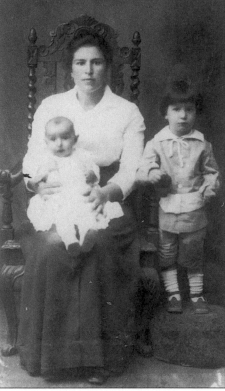

Here we see Cesidia (Pellegrini) Antonellis with the two eldest children, Nunziato (right) and Maria, in a 1917 portrait. Eventually, the family would grow to five children, two boys and three girls. (Courtesy of Mary [Antonellis] Cuggino.)

Mary (Antonellis) Cuggino, who married building contractor Nazzareno Cuggino in 1938, is seen here in 1940 in the backyard of her Brighton home. She is wearing a traditional Italian costume from the Ciociaria region of Italy that had belonged to her grandmother, Maria Cedrone of San Donato val di Comino. (Courtesy of Mary [Antonellis] Cuggino.)

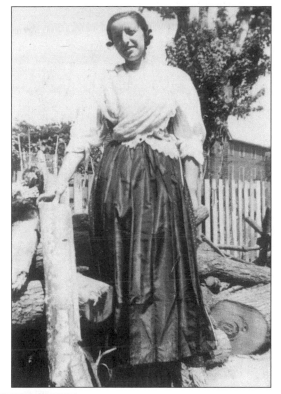

Cesidia (Pellegrini) Antonellis and Donato Antonellis celebrated their 50th wedding anniversary at Newton's Chestnut Hill Country Club in 1954. (Courtesy of Mary [Antonellis] Cuggino.)

75

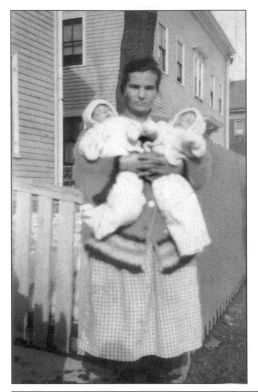

When Cesidia Salvucci arrived in America in March of 1924, she was pregnant with twins, born that October. A combination of seasickness and morning sickness made the voyage a terrible ordeal for this immigrant woman, who had never before been at sea. Here, she stands outside her house on Brighton's Snow Street with her newborns, a boy and a girl, Ideale and Olinda. Olinda, died at age four in 1928, a victim of diphtheria. (Courtesy of Antonetta Salvucci.)

In 1926, Cesidia Salvucci was expecting still another set of twins. This photograph of Cesidia and her children was taken on the grounds of the Chestnut Hill reservoir in Brighton. The children are, from left to right, as follows: Antonetta, Olinda, Ideale, and Maria. In all, Cesidia gave birth to seven children, an average size family among Italian immigrants. (Courtesy of Antonetta Salvucci.)

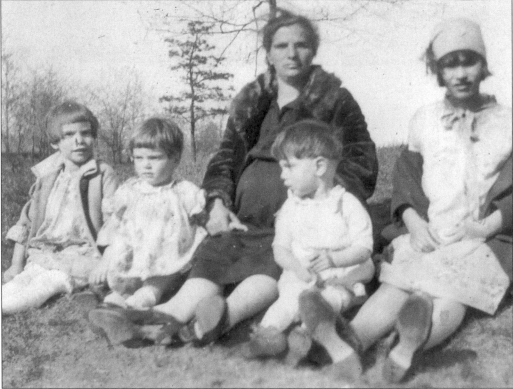

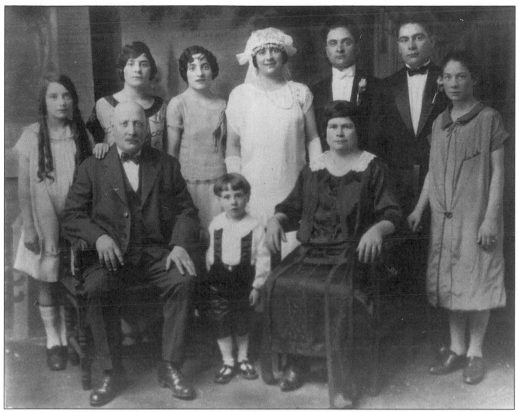

Italian weddings were typically very elaborate affairs. A successful wedding was judged by the number attending and the variety of food and drink offered to guests. Relatives and friends of all ages were invited. Luigi and Maria (Diorio) Mazzulli of South Boston were married in 1925. Carmine Diorio, the bride's father (seated to the left), ran a grocery store, CD's, at Emmett and Third Streets in the heart of South Boston's Italian enclave. (Courtesy of Terri Mazzulli.)

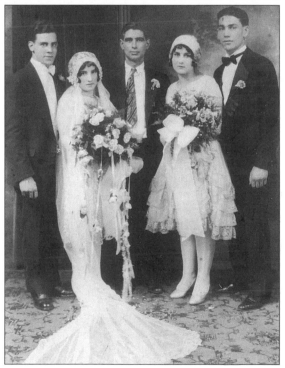

This wedding portrait of Margaret Pietracatella and Gaetano Panarello of Chelsea was taken in 1928. Other members of the wedding party include Antonio Giordano, stepfather of the bride (center), maid of honor Mary Addonizzio, and best man Nicholas Pettis. (Courtesy of Marge [Panarello] DiSciullo.).

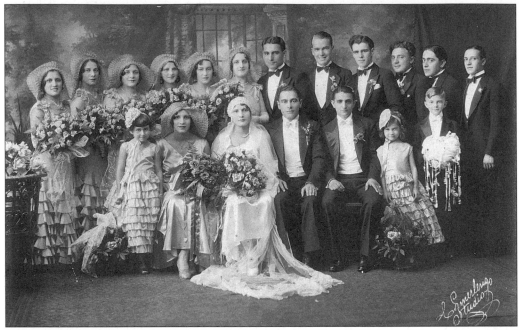

Large families tended to produce large wedding parties. Joseph Diorio of South Boston and Viola D'Este of East Boston were married in 1931. Here is their elaborately outfitted 19-member wedding party. (Courtesy of Terri Mazzulli.)

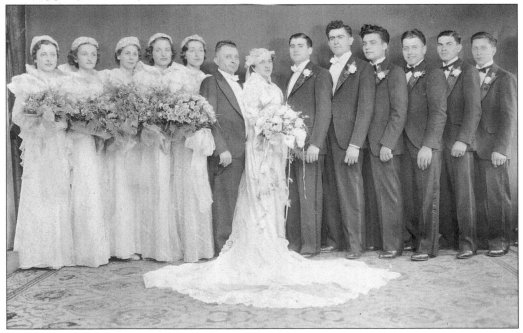

The wedding party at the June 1936 nuptials of Carmine Quintiliani of Newton and Lucy Piselli of Brighton offers another excellent example of a large wedding party. Weddings were important social events in the Italian community. Mary Antonellis (the maid of honor) stands fifth from the left in this photograph, while her future husband, Nazzareno Cuggino, stands second from the right. (Courtesy of Mary [Antonellis] Cuggino.)

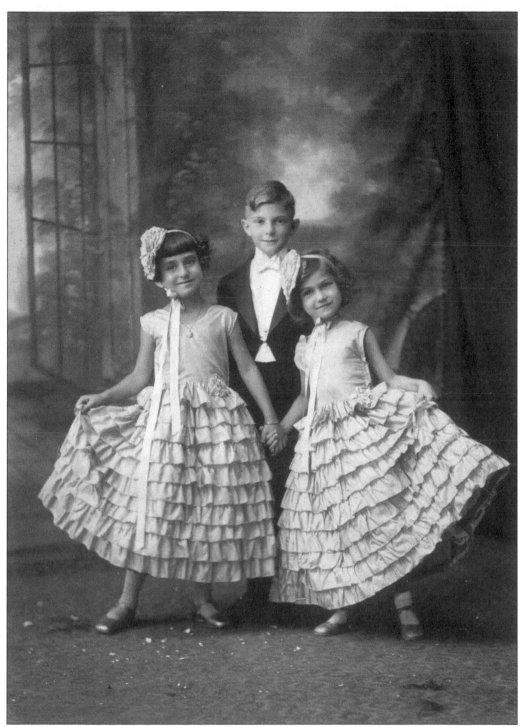

Children often played a key role in Italian wedding festivities. Here, three handsomely outfitted children participated in the Diorio-D'Este wedding, serving as flower girls and ring bearer. The flower girl to the left is Teresa Mazzulli, and the ring bearer is Bobby Campania. The identity of the second flower girl is uncertain. (Courtesy of Terri Mazzulli.)

The Bonsignore family of East Cambridge attended this wedding reception in 1947. The young man at the center is Salvatore Bonsignore, who had recently returned from service in the Marine Corps. His father, Vittorio Bonsignore, is to the left of him. (Courtesy of Anthony Ricciardi.)

After the death of her widowed mother, Gisella Marchi, the only sister in the Marchi family, kept house for her brothers. Gisella never married. She also brought up her niece, Marie Marchi, when family health problems disrupted the little girl's immediate family. Here we see Gisella and little Marie in 1920, behind the Marchi family's home at 45 Derby Street, Somerville. (Courtesy of Marie [Marchi] Bonello.)

Members of the LoPiccolo family are seen here in the 1950s leaving Chambers Street in Boston's West End for a family picnic at Stage Fort Park in Gloucester. (Courtesy of Joseph LoPiccolo.)

Members of the Pepi family and friends are enjoying a picnic lunch in the woods near their home in Worcester in this *c.* 1940 photograph. (Courtesy of Laura Pepi Bain.)

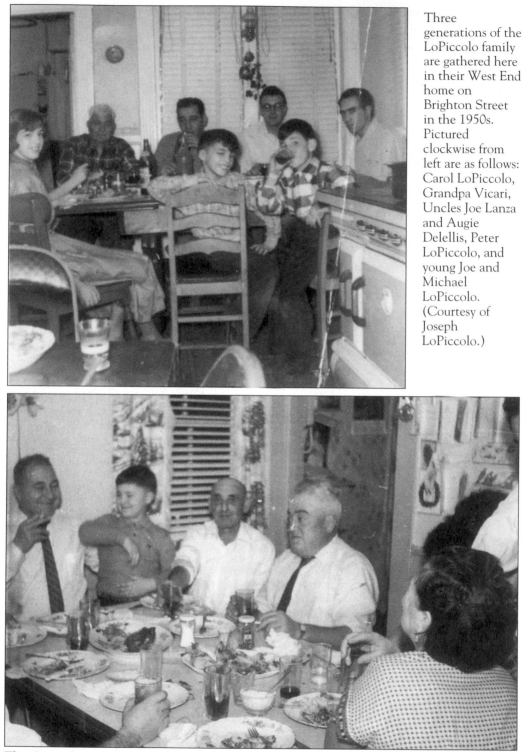

Three generations of the LoPiccolo family are gathered here in their West End home on Brighton Street in the 1950s. Pictured clockwise from left are as follows: Carol LoPiccolo, Grandpa Vicari, Uncles Joe Lanza and Augie Delellis, Peter LoPiccolo, and young Joe and Michael LoPiccolo. (Courtesy of Joseph LoPiccolo.)

The Crognales eat Sunday dinner in their North End home in January 1961. (Courtesy of Francine and Cleto Crognale.)

Members of the Marchi family are enjoying one another's company in the kitchen of their Derby Street, Somerville home in the 1940s. Battista Marchi sits second from the left, while Gisella and Marie Marchi sit to the right. (Courtesy of Marie [Marchi] Bonello.)

Filomena Buonanduci and Antoinette Caprio are preparing baked goods for a public reception that the town of Swampscott is about to give. The reception is in honor of family member Michael Buonanduci (right) on the homecoming of the Korean War POW in the early 1950s. (Courtesy of Sylvia Curato.)

Members of the Tocci family of Newton are shown here at Christmas dinner, c. 1950. From left to right are as follows: Virginia (DeGregorio) Tocci, John Tocci, and their daughter, Anna [Tocci] Marzilli. (Courtesy of Bud Lombardi.)

Members of the Tocci family of Newton are seen preparing polenta in the 1980s. Visible are Marilyn (Lombardi) Antonellis, Anna (Tocci) Marzilli, and Germania (Tocci) Clardy. (Courtesy of James Cummings.)

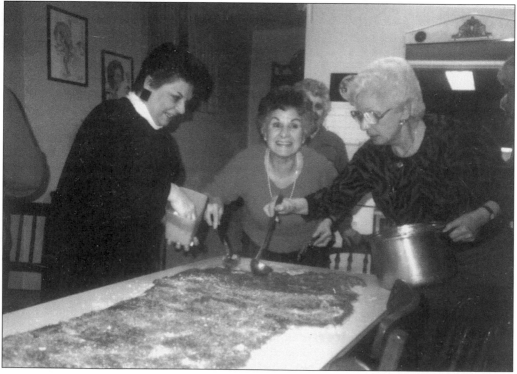

Seven

BUSINESS AND LABOR

It was in the realm of business that Italian Americans made their first substantial gains. Most of the early Italian-owned enterprises depended, of course, on the patronage of local immigrant residents. The Italian-owned banks, import-export businesses, funeral parlors, liquor stores, restaurants, pharmacies, and clothing stores not only generated wealth for their proprietors, but helped create a class that provided much of the early leadership in the Italian community.

Especially notable in the early period were the successes of financier John Deferrari, Pietro Pastene, founder of Pastene & Company, and John Cifrino, who established the nation's first supermarket chain. However, a second layer of entrepreneurial activity had an even greater impact. Small-scale enterprises such as barbershops, bakeries, groceries, tailoring establishments, fruit stores, and shoe repair shops provided an essential leavening that raised many Italian families to a measure of comfort and security.

Yet the great majority of Italian Americans continued to work for wages. As late as the 1930s, more than half of Boston's adult male Italians still earned their livelihood as ordinary day laborers.

Earning a living had always been the first concern of the poor immigrant, and his pattern of settlement reflected that all-important preoccupation. In the case of the Italians of Boston's North and West Ends, it was the job opportunities in the market district, on the waterfront, and in downtown manufactories that drew Italians to those neighborhoods. Italian merchants plied their trade at the Faneuil Hall and Blackstone Street markets. A sizable, largely Sicilian-owned fishing fleet, operated out of T Wharf on the Boston waterfront. North End labor agents organized Italian work crews to send out to major construction projects, sometimes hundreds of miles from Boston. Jobs in local industry, in construction, in grounds keeping, and a myriad of other occupations drew Italian immigrants into the many suburban enclaves that ringed the metropolis. In the more distant urban centers, it was usually employment opportunities in manufacturing that drew in the job-hungry immigrant.

The era of the Great Depression was a particularly painful one for the Italian Americans, situated as they were near the bottom of the social and economic pyramid. Even low paying day laboring jobs were now in short supply. In addition, Italians faced discriminatory hiring practices in the private sector as well as a denial of their fair share of local, state, and national relief. Discriminatory policies also denied them access to public housing units.

Major change came after 1945. The general prosperity that prevailed in the post–war era, the years from 1945 to 1970, lifted Greater Boston's Italian community to unexampled heights of prosperity. The prosperous economic climate not only fostered enterprise, but also encouraged many more young Italian Americans to seek higher education. The list of Italian Americans who rose to distinction in these years is long and impressive. Major building firms like Perini and Volpe Construction offer one obvious example, but there were also countless successes in

the world of banking, commerce, trade, engineering, law, medicine, and scholarship. By the 1970s, Italian Americans had entered Boston's economic mainstream.

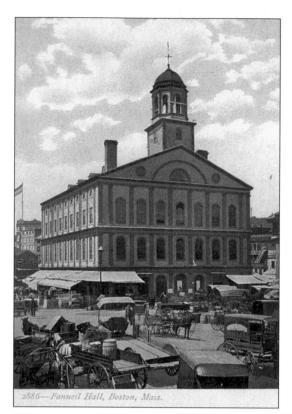

2886—Faneuil Hall, Boston, Mass.

Faneuil Hall Market quarter was still serviced by horse-drawn conveyances in the very early 1900s. Many Italian pushcart vendors and other purveyors of meat, fruit, and vegetables maintained businesses in and around Faneuil Hall.

The Faneuil Hall and adjacent Quincy markets, as seen in this 1911 view, were early focal points of the economic life of Boston's Italian community.

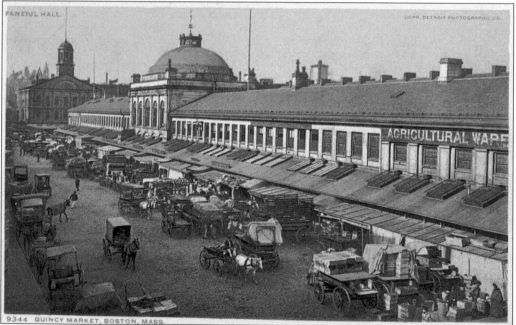

9344 QUINCY MARKET, BOSTON, MASS.

The facilities provided by the Faneuil and Quincy markets proving insufficient, Italian food vending establishments soon spread out along neighboring Blackstone Street, which accommodates an outdoor market to this day. (Though today it is greatly reduced in size.) Here, a Blackstone Street vendor sells fresh produce in the 1950s. (Courtesy of Joseph LoPiccolo.)

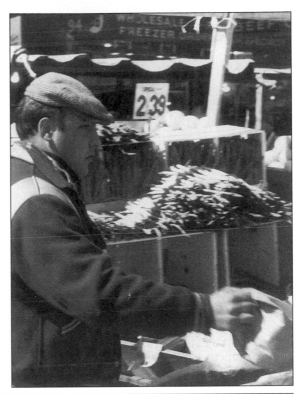

It was at about the time that this photograph of T Wharf was taken in 1900 that Italian immigrants began to play an essential role in the life of the local fishing industry. The influx of Roman Catholics into the city at the end of the 20th century had proven to be a great boon to that industry. (Courtesy of Jimmy [Bono] Geany.)

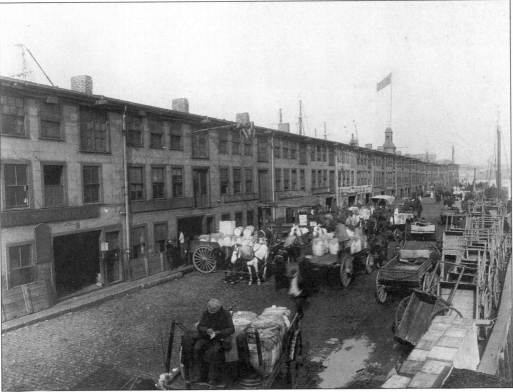

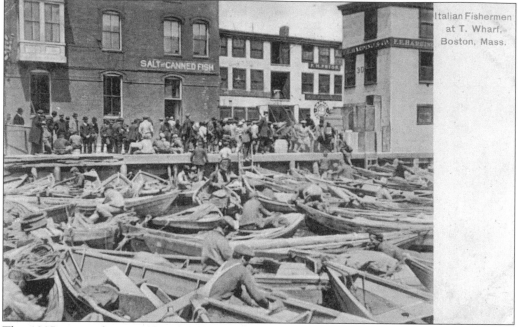

This 1907 postcard view of T Wharf bears the caption, "Italian Fishermen at T Wharf, Boston, Mass." With the removal of much of the Boston fishing fleet to facilities in South Boston in 1914, the city's Italian fishermen, who were chiefly Sicilians, had come to dominate T Wharf.

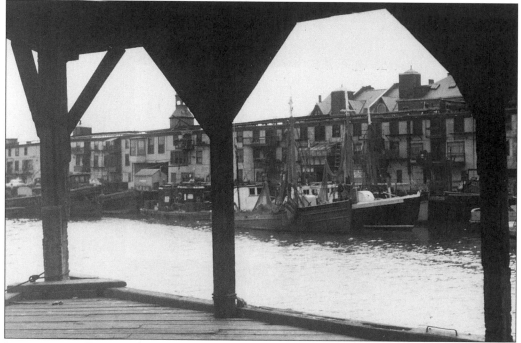

Here we see T Wharf and a part of the Italian Fishing Fleet about 1930. Italians specialized in catching flounder, herring, eels, crabs, and other shellfish, which they supplied to wholesale firms for sale to Italian enclaves around the country. They also were the principal providers of fish to the city's poor. (Courtesy of Vito Aluia.)

This view of T Wharf in the 1930s shows the Italian fishing boat *Santina D* in the foreground. Notice the men to the right repairing a fishing net. (Courtesy of Vito Aluia.)

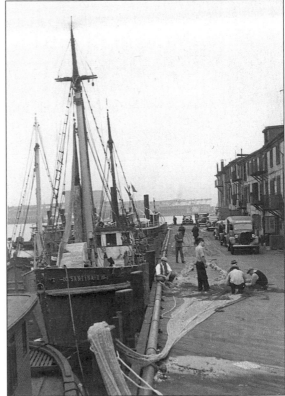

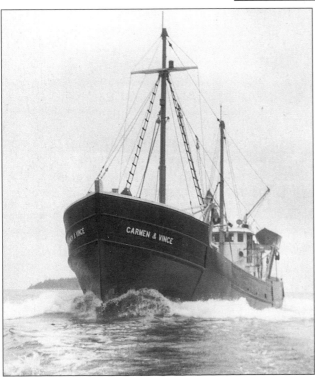

This vessel, the *Carmen & Vince*, a fishing trawler, was owned by Vincent (Jimmy) Bono of Boston and operated out of T Wharf. It was built in Maine in the early 1960s. (Courtesy of Jimmy [Bono] Geany.)

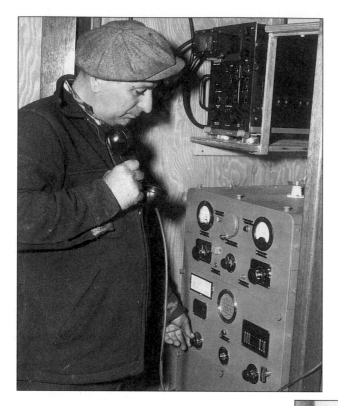

Vincent (Jimmy) Bono is seen here in the pilothouse of his boat, the *Carmen & Vince*. A well-equipped vessel with a modern radio, it was a great improvement over the primitive craft that Jimmy's father, Raimondo Bono, had utilized earlier in the century. At that time, Boston fishermen set their course in and out of Boston harbor by the lights of Boston's Customhouse tower. Ironically, this modern vessel sank in a storm on George's Bank in 1966. (Courtesy of Jimmy [Bono] Geany.)

Part of the Boston fishing fleet moved to Gloucester about 1910. Italian-owned vessels still make up an important part of the fishing fleet in both ports. Here, the fishing vessel *Giuseppe & Lucia* is out on its maiden voyage in 1939. The vessel was the property of the Brancaleone family of Gloucester. (Courtesy of Jean [Burgarella] Anjoorian.)

In 1947, Italian-American businessmen John Deferrari gave $3 million to the Boston Public Library, one of the largest public bequests in the history of the city. Born in the original Italian enclave in the North End in 1865, Deferrari was a self-made man who taught himself real estate law, business, economics, and statistics by reading books borrowed from the Boston Public Library. Deferrari Hall at Copley Square library was named in his honor. (Courtesy of the Boston Public Library.)

Another highly successful Italian-American businessman was John Cifrino, born in Prepazzano, Province of Salerno, in 1879. Cifrino immigrated to Boston in 1895 at age 16. In 1901, he opened the Upham's Corner Market, in Dorchester, which eventually developed into the world's largest market, considered the first supermarket in the country. Subsequently, Cifrino served as president of the Supreme Markets. (Courtesy of the Boston Public Library.)

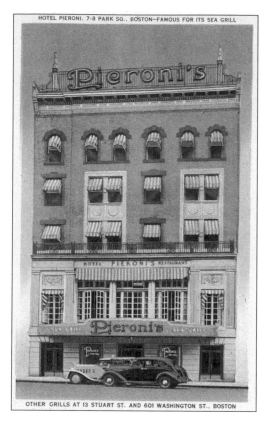

HOTEL PIERONI, 7-8 PARK SQ., BOSTON—FAMOUS FOR ITS SEA GRILL

OTHER GRILLS AT 13 STUART ST. AND 601 WASHINGTON ST., BOSTON

Many Italian businessmen attained success through the establishment of first class restaurants. One of the best was Pieronis, at 7-8 Park Square, in Boston, which served both as a hotel and restaurant.

Restaurateur Marciano Di Pesa, pictured here, immigrated to Boston in 1883. Shortly thereafter, he opened the Hotel Italy in North Square in Boston's North End. About 1910, Di Pesa purchased a run down hotel at 84 Friend Street in the West End, renaming it the Hotel Napoli, and turned its 600-seat dining room into one of the finest restaurants in Boston.

The dining room of the Hotel Napoli is shown here. One source noted of this fine restaurant, "During the evening popular and classical music is rendered by an excellent orchestra..." and "only the best foodstuffs are served and the cuisine and service are perfect."

Italians also distinguished themselves as chefs. Edward Bonello of Somerville was chief chef at the Parker House for 20 years, succeeding his uncle John Bonello, who in 1935 had been named one of the "ten best chefs in the United States." Edward later held the post of chief chef at the Harvard Club. His brother, Mario, was likewise a distinguished chef. The Bonello family immigrated to the United States from Serravalle d'Asti in the Piemonte region of northwest Italy. (Courtesy of Marie [Marchi] Bonello.)

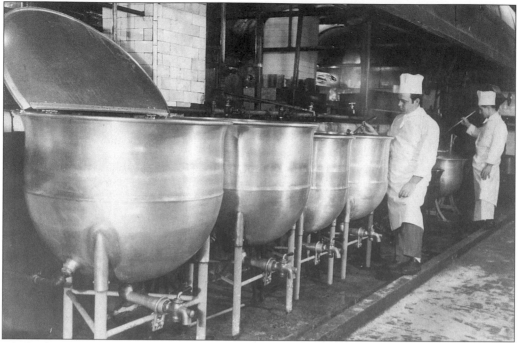

Chef Edward Bonello (extreme right) is seen here in the kitchen of Boston's Parker House Restaurant. (Courtesy of Marie [Marchi] Bonello.)

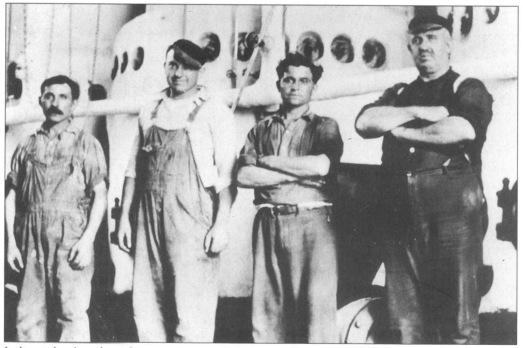

Italians also found employment in manufacturing establishments such as the Kendall Company in Walpole. Shown in this 1931 photograph, taken in the Kendall Company boiler room, from left to right, are as follows: Giacomo Silvi, Giuseppe Ciannavei, Giovanni Silvi, and supervisor Harry Giles. (Courtesy of Guy Ciannavei.)

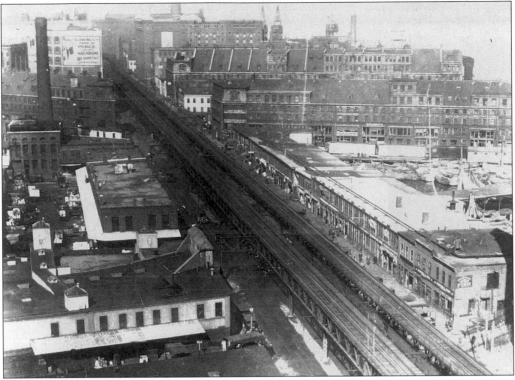

Sometimes Italians established their own highly successful manufactories. At the top left corner of this photo of Commercial Street in the North End in the 1930s is a billboard that then stood atop the Prince Macaroni Company. Prince was an Italian-owned enterprise that had its beginnings on the North End's Prince Street. (Courtesy of Jimmy [Bono] Geany.)

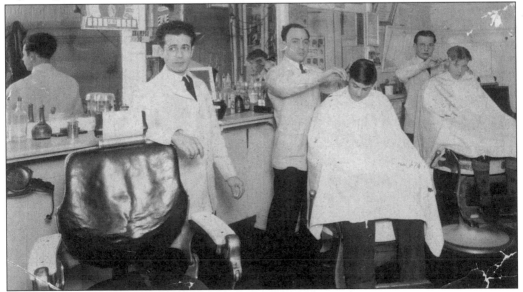

Many Italians opened barbershops, like Frank's Barbershop on Market Street in Brighton, seen here in the 1930s. The central figure, owner Frank Curatolo, immigrated to the United States from Mazarra, Sicily, at age 11, in the early 1920s. (Courtesy of the Curatola family.)

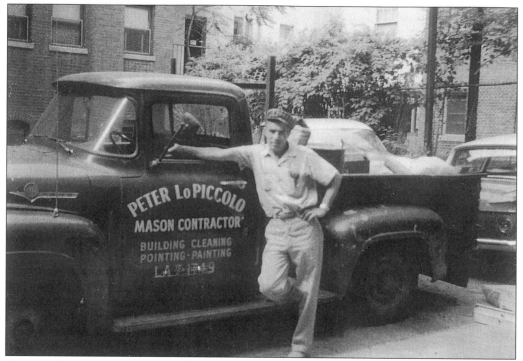

Many Italians earned their livelihood in the building trades. West End masonry contractor Peter LoPiccolo is seen here with his truck in the 1940s, a decade that saw the establishment of many small construction firms by Italian Americans. (Courtesy of Joseph LoPiccolo.)

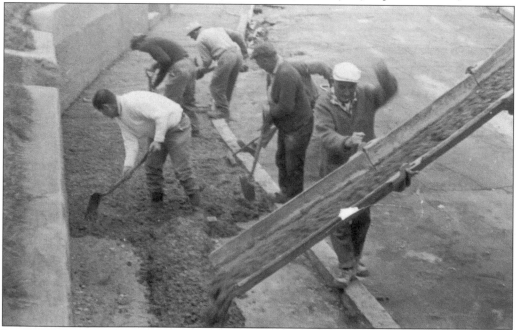

Paving contractor Pompeo Rufo and his crew are at work on a sidewalk in downtown Boston in the 1950s. Pompeo and his twin brother, Candido, established the Brighton Construction Company just after WWII. (Courtesy of Adeline [Perruzza] Rufo.)

Master mason Cleto Crognale is seen making repairs on the Harvard University campus in the 1990s. (Courtesy of Francine and Cleto Crognale.)

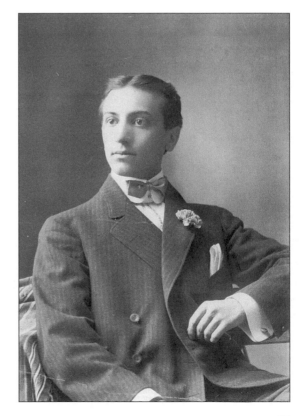

John Vinti, who emigrated from Naples to Newport, Rhode Island, in 1898, established a highly successful tailoring business in that city in the early years of the century. The always impeccably dressed Vinti was a walking advertisement for his business establishment. In 1923, he moved his tailoring establishment to 1308 Commonwealth Avenue in Allston. (Courtesy of Anna [Vinti] Edmonson.)

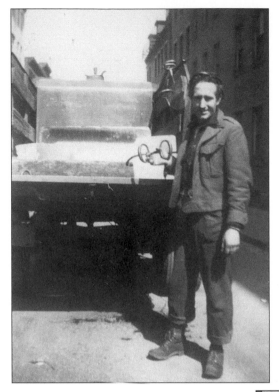

In a day when many products were still delivered by wagon, iceman Willy Vicari makes a delivery in the 1950s in the West End. (Courtesy of Joseph LoPiccolo.)

Antonio Lombardi, a noted portrait photographer, stands outside his studio at 232 Clarendon Street in Boston's Back Bay in the 1960s. Born in Naples, he came to Boston as an infant. Lombardi became a favorite photographer of the city's older families, from both the Yankee and Italian communities. His political clients included such well-known figures as U.S. Senator Leverett Saltonstall and Governor Christian Herter. The Lombardi Portrait Studio also specialized in "coming-out" portraits of Boston debutantes. (Courtesy of Beatrice [Lombardi] Coyne.)

Eight

RELIGION AND PHILANTHROPY

Boston's Italians were at a major disadvantage in the realm of religion. As Catholics, they were members of a church that aroused deep suspicion, even hatred, in the minds of the nation's Protestant majority. A further and even more important disadvantage stemmed from the control the earlier-arriving Irish had established over Boston's Catholic hierarchy and institutions. Ironically, the common religious bond that the city's Irish and Italians shared damaged rather than enhanced the relationship of these ethnic groups.

The Irish had a rather different conception of Catholicism from that of the Italians. Irish religious practice was more pietistic, Italian more emotional. As one historian of the Italian religious experience in America has observed, while the two groups belonged to a common church, they in fact practiced substantially different religions.

The relationship between Italians and the Boston area Catholic Church therefore proved very difficult in the early years. It was punctuated by disputes over church autonomy, control of church revenues, the appointment of Italian priests, and the use of the Italian language in services. Another dispute stemmed from what was called an excessive attachment of Italian parishioners to their regional saints and traditional ceremonies.

The Irish had fought long and hard to establish their dominant position in the Catholic hierarchy of Boston. That control was a source of great pride and prestige to the Irish community. Therefore, the Catholic leadership in Boston was perhaps understandably reluctant to concede very much autonomy to an element that engaged in forms of worship of which it strongly disapproved.

Seeking a degree of self-determination in church matters, the various Italian immigrant communities of Greater Boston established nearly 20 Italian-language churches in the early years. In the North End, St. Leonard's Church, founded in 1879, was the second oldest Italian-language church in the nation. In East Boston, Somerville, Waltham, Framingham, Milford, and Worcester, among other localities, churches were founded. They would certainly have established others had it not been for the opposition of the church hierarchy, led, after 1907, by the redoubtable William Cardinal O'Connell.

In addition, the Irish resented the anti-clerical sentiments that many Italian immigrants evidenced. This anti-clerical outlook stemmed, at least in part, from a very different historical relationship to the church. Whereas in Ireland, Catholicism had long served as a rallying point against British Protestant oppression, in Italy the church had been a bastion of the upper classes and a formidable obstacle to reform. It had opposed, for example, the unification of Italy. Once

that was accomplished, between 1861 and 1870, it had refused to recognize the legitimacy of the united Italy, advising Italian Catholics to withhold support from the government. In addition, the Socialist movement, the largest political party in Italy at the turn of the 20th century, was strongly anti-clerical.

Despite these conflicts, however, major elements in the Italian community maintained a strong attachment to the Catholic Church and its institutions. In addition to establishing many Italian-language churches, the community contributed to the development of a broad range of philanthropic and charitable institutions under church auspices. Most notable of these was the Home for Italian Children in Jamaica Plain and the Don Orione Home in East Boston.

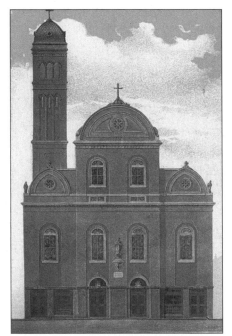

North Square lay at the center of Boston's oldest Italian enclave. Indicative of the rise of Italians to a dominant position in the neighborhood was the establishment, in 1888, of Sacred Heart Church, which offered services in Italian. The church building, dating from 1828, had earlier served as a Protestant house of worship, the Seamen's Bethel, which attended to the spiritual needs of mariners. (Courtesy of Vito Aluia.)

An interior view of Sacred Heart Church in North Square in Boston's North End shows an inset of the facade when the building was acquired in the 1880s. (Courtesy of Vito Aluia.)

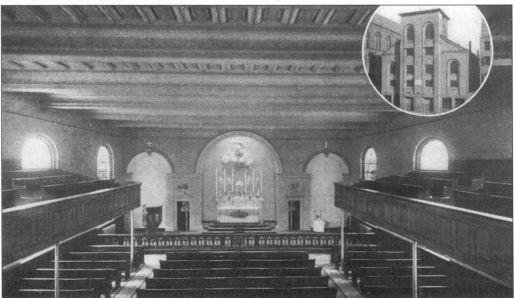

Critical to the success of the Italian language churches around Boston were the services of dedicated Italian priests such as Father Pietro Maschi. In 1907, Maschi founded St. Tarcisius Church in Framingham to serve that community's growing Italian population. Born in Ravarano, Province of Parma, in 1879 and ordained in Italy, Father Maschi came to America in 1904. After brief service as a curate in New York, Boston, and Providence, he was assigned to Framingham, where he oversaw the construction of St. Tarcisius Church and held the post of pastor for the next 33 years.

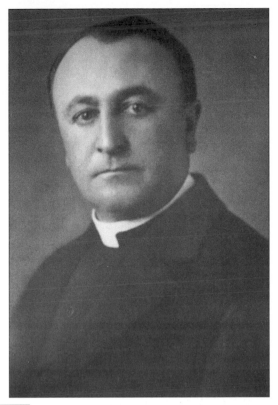

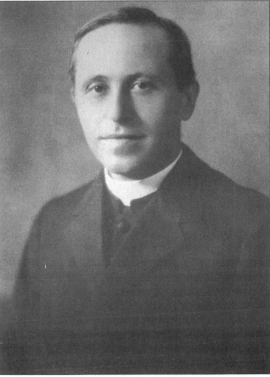

Another dedicated Italian priest was Father Nazareno Properzi, who founded St. Anthony's Church in Somerville's Italian enclave. Born in Corridonia, Province of Macerata, in 1890 and ordained in Italy, he came to America in 1914 and served briefly as assistant pastor at Sacred Heart Church in the North End. In 1916, the young priest founded St. Anthony's, holding the position of pastor for the balance of his life. Father Properzi also served as Somerville Recreational Commissioner and on the board of the Home for Italian Children.

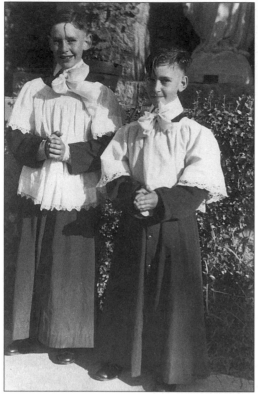

Joseph and John Burgarella are seen serving as altar boys at St. Peter's Church in Gloucester in 1935. (Courtesy of Jean [Burgarella] Anjoorian.)

Mary Tocci stands outside her home on Union Street in Brighton with her sisters. Shown, from left to right, are Kay, Linda, and friend, Patty Bryson, following Mary's First Communion in 1952. (Courtesy of Mary [Tocci] Regan.)

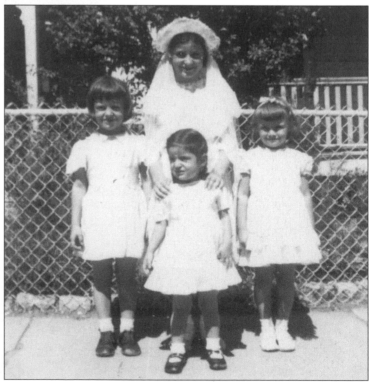

North Ender Vito Aluia receives his First Communion at Sacred Heart Church in 1954. (Courtesy of Vito Aluia.)

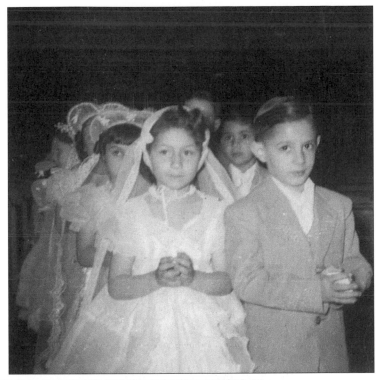

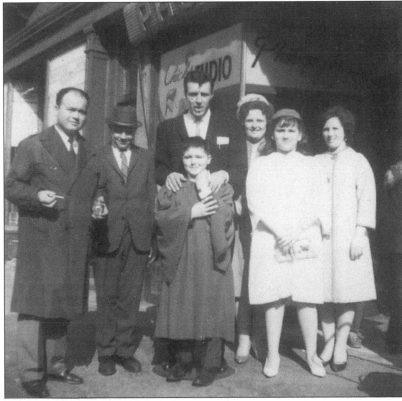

Thirteen-year-old Gabriel Crognale stands with family members outside St. Stephen's Church on Hanover Street in the North End in April 1964, following his confirmation. Behind Gabriel stands his godfather, Frank Susi. (Courtesy of Francine and Cleto Crognale.)

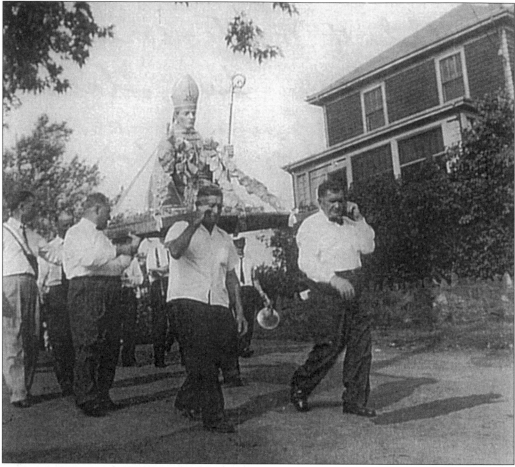

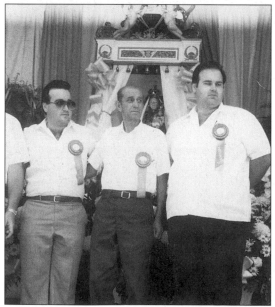

A statue of San Giovanni di Montemarano is carried through the streets of Swampscott's Italian neighborhood in the 1950s. Much Italian religious activity revolved around saints day observations. (Courtesy of Sylvia Curato.)

The statue of the Madonna del Soccorso, patron saint of the fishing fleet, is being taken from its permanent home at the Fishermen's Club in Boston's North End in this 1986 photograph. (Courtesy of Jimmy [Bono] Geany.)

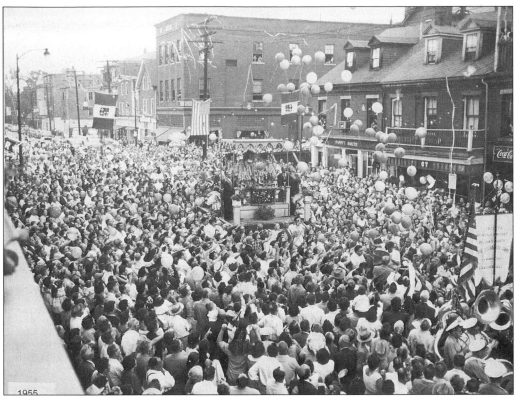

Religious processions were held wherever Italians settled in significant numbers. This 1955 view is of the St. Alfio Procession on Common Street in Lawrence. (Courtesy of Jimmy [Bono] Geany.)

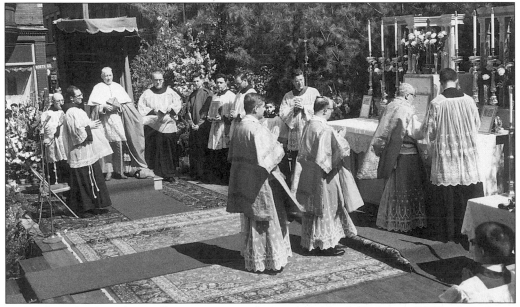

Richard Cardinal Cushing officiates at an outdoor mass in North Square in the North End, just outside Sacred Heart Church in the 1950s. (Courtesy of Vito Aluia.)

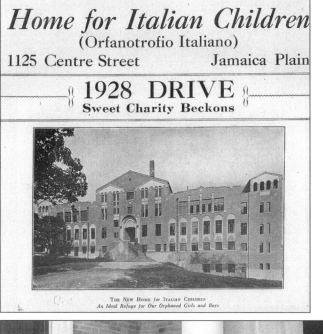

Home for Italian Children
(Orfanotrofio Italiano)
1125 Centre Street Jamaica Plain

§ 1928 DRIVE §
Sweet Charity Beckons

THE NEW HOME for ITALIAN CHILDREN
An Ideal Refuge for Our Orphaned Girls and Boys

The Home for Italian Children was founded on October 10, 1919, to provide care for girls orphaned by the devastating Spanish Influenza Epidemic. Participants in its organizational meeting included grocer Carmine Antonio Martignetti; lawyers Felix Forte, Vincent Brogna, and Principio Santosuosso; banker Andrew DiPietro; Industrial Accident Board inspector Ernest Martini; businessman John Deferrari; fruit dealer Thomas Nutile; restaurateur Antonio Polcari; and dry cleaning chain owner James Sarni. (Courtesy of the Italian Home for Children.)

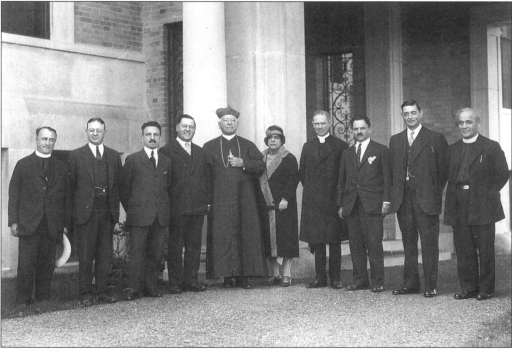

In this 1927 photograph are some of the earliest supporters of the Home for Italian Children. Appearing from left to right are as follows: Reverend Peter Maschi, pastor of St. Tarcisius Church, Framingham; Boston University School of Law Professor Felix Forte; inspector Ernest Martini; contractor Joseph A. Tomasello; William Cardinal O'Connell; Luisa Deferrari; Archdiocesan Chancellor Monsignor Richard J. Haberlin; restaurateur Antonio Albiani; supermarket owner John Cifrino; and Reverend Romono Simoni of Our Lady of St. Carmel Church, East Boston. (Courtesy of the Italian Home for Children.)

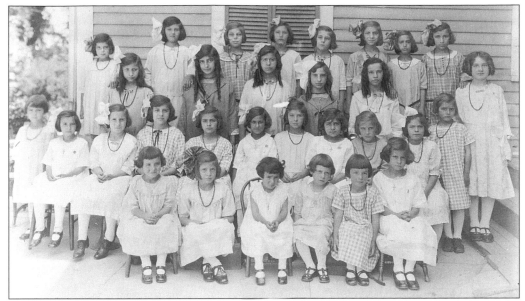

The founders of the Home for Italian Children purchased the 10-acre Gahm Estate on Centre Street in Jamaica Plain as a site for the charitable institution. The property included a barn, caretaker's residence, fruit trees, a vegetable garden, and an extensive hilltop view of Boston. Boys were admitted to the home for the first time in 1929. (Courtesy of the Italian Home for Children.)

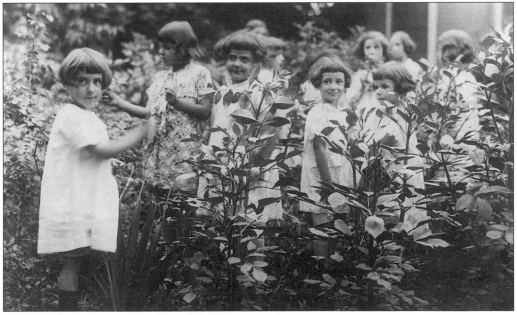

William Cardinal O'Connell arranged for Sister Mary Valentina, a teacher at St. Anthony's School in the North End and a member of the Order of Missionary Franciscan Sisters of the Immaculate Conception, to serve as Superior of the Home for Italian Children. Members of that order also staffed the facility. This early 1920s view shows the children enjoying the plants and flowers on the grounds of the Jamaica Plain property. (Courtesy of the Italian Home for Children.)

Baseball great Joe DiMaggio instructs a young boy in batting techniques. The slugger visited the Home for Italian Children about 1938. (Courtesy of the Italian Home for Children.)

Maria Bonsignore (left) and friends, members of the Friends of Mary, a society organized under the auspices of the St. Francis of Assissi Church, East Cambridge, raised money to support the Home for Italian Children in the 1930s. (Courtesy of Anthony Ricciardi.)

Nine

CULTURE AND
EDUCATION

Italians, with their strong artisan traditions, have made a major contribution to the cultural and educational life of Greater Boston. Many arrived in Boston as highly skilled painters, sculptors, mosaic and marble workers, woodworkers, and landscape architects, in an era when there was much need of such skills. Their contributions to the beautification of public spaces, though largely unheralded, have been quite significant. Others came as skilled musicians, who were quickly enlisted by the region's leading symphonic, chamber music, and operatic companies. Oftentimes, the children of talented immigrants carried their parent's occupations into the next generation.

One of nation's leading composers, Walter Piston, was of Italian ancestry. His grandfather, a Genoese sea captain, Antonio Pistone, had settled in Rockland, Maine, in the early 1860s. Though born in Maine, Piston lived most of his adult life in the Boston area, as a resident of Belmont and member of Harvard University's music faculty.

Especially notable were two North End–born women, Elisa Biscaccianti and Elvira Leveroni, who rose to the heights of their profession as great divas, performing in many of the world's leading opera houses. Another North Ender, Silvio Risegari, was a concert pianist of international stature.

Italian-American contributions to sculpture have been especially significant. Joseph Colletti, who came to America from San Donato val di Comino in 1898, and who grew up in Quincy, served as an assistant to John Singer Sargent before launching a highly successful sculpting career. Ernest Pellegrini, born in Sant' Ambrogio di Valpolicella, Province of Verona, arrived in Boston in 1913, having been trained at Italian art schools. Pellegrini later established a school of sculpture in Boston's Copley Square, which trained many talented young sculptors of the day. Addio di Biccari, who grew up in East Boston, studied with Pellegrini and later with Charles Dallin at the Massachusetts College of Art, before launching a notable career in that field. His brother-in-law, Archangelo Cascieri, who also trained as a sculptor, is perhaps best remembered as the long-time dean of the Boston Architectural Center.

The Italian-American contribution to literature is best exemplified by the life and career of great poet John Ciardi of Medford. An editor of the Saturday Review of Literature, his major works included a widely heralded translation of Dante's Divine Comedy.

Boston's Italian-American community contributed in significant ways also to popular culture through the performances of Italian bands, musicians, singers, theatrical companies, and entertainers of almost every kind.

Contributions in the field of education have been equally significant. Italian Americans have served as presidents of Boston College, the College of the Holy Cross, and Tufts University. In addition, countless Italian Americans have served as administrators and faculty members at area universities, colleges, and public and private schools.

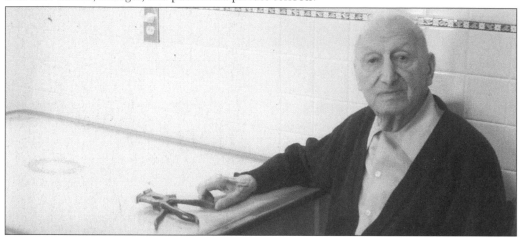

Many Italian immigrants were highly skilled craftsmen. Michael Totino, age 94, a tileman, is seen here in the kitchen of his Arlington home in 1999. The son of Luigi Totino, the man who supervised the laying of the magnificent mosaic floors in the Hall of in the Massachusetts State House in 1892, Michael holds the mosaic-laying tool his father used while supervising that project. The elder Totino lived at 79 Prince Street in the North End at the time that the work was completed. (Courtesy of Michael Totino.)

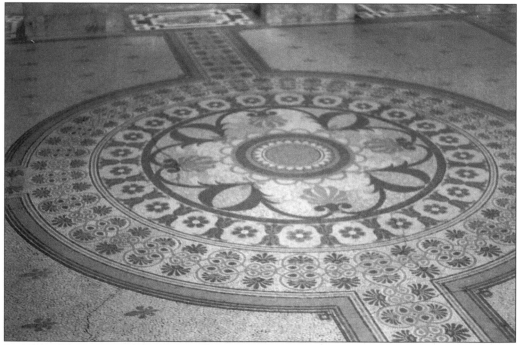

In 1892, this portion of the mosaic floor in the Massachusetts State House was installed by a team of Italian craftsmen under the supervision of Luigi Totino. The elder Totino also helped lay the mosaics at Fenway Court, now the Isabella Stewart Gardner Museum.

In 1984, a plaque was put up in the State House to recognize Luigi Totino's contributions. The plaque reads, "Luigi Totino, 1865–1955. In recognition of his contribution as the marble and mosaic artisan who supervised the laying of the tile floor in the Hall of Flags."

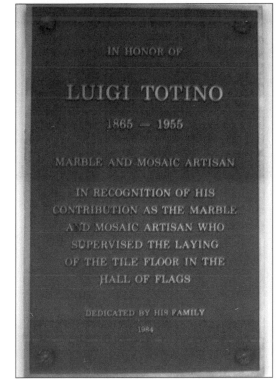

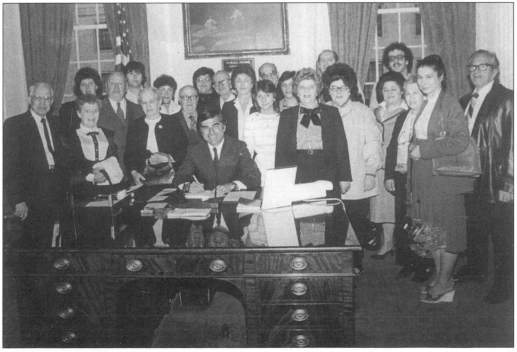

Members of the Totino family are seen here in 1984 with Massachusetts Governor Michael Dukakis at the dedication of the plaque in memory of master artisan Luigi Totino. (Courtesy of Michael Totino.)

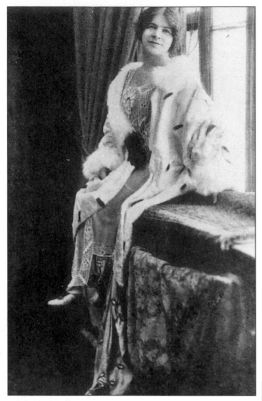

From the beginning, music was an important facet of the life of Boston's Italian community. Born in the North End in 1885, Elvira Leveroni's first singing experience was as a member of the choir of the North End's Sacred Heart Church. She later studied voice in Italy, rising to great prominence in the world of opera. In 1908, Elvira Leveroni joined the Boston Opera Company and later sang with New York's Metropolitan Opera, appearing with Enrico Caruso.

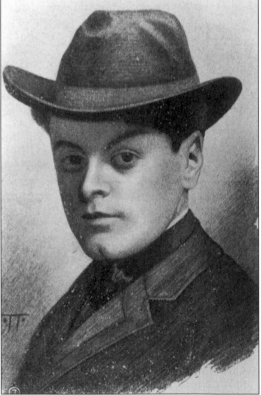

Boston's Italian immigrant community was also home to the internationally known concert pianist Silvio Risegari. Born in Genoa in 1877, Risegari came to Boston as a young man and studied the piano with Clayton Johns. An officer of the North End's Sacred Heart Church, Risegari performed extensively both in the United States and abroad as a soloist and with various orchestras.

Since music was an important part of cultural life in the homeland, talented musicians were plentiful in Italian communities in America. This Italian marching band was organized in Haverhill in the late 19th century. (Courtesy of the Boston Public Library.)

Of the many Italian bands, none was more popular than the Roma Band, founded in the North End in 1910. In this photograph, the Roma Band winds its way through the streets of the North End in the 1950s. (Courtesy of Joseph LoPiccolo.)

The Roma Band performs at the Fisherman's Feast on North Street in the North End in 1974. The director of the Roma Band for most of its long history was the late Gaetano Giarraffa. (Courtesy of Jimmy [Bono] Geany.)

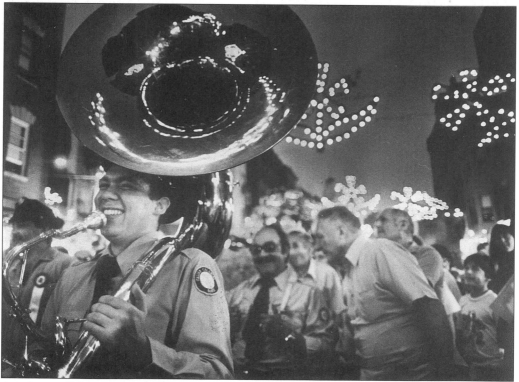

Another well-known band, the Italian Colonial Band, is seen marching on the North End's Hanover Street in the 1970s. (Courtesy of Jimmy [Bono] Geany.)

TONY LAVELLI "ALL AMERICAN ACCORDIONIST"

Many Boston Italians entered the entertainment field. Unique among them was Tony Lavilli, with his combination of outstanding musical and athletic talent. Lavilli, who grew up in Somerville and graduated from Yale, was a nationally known accordionist and composer. He performed on the *Ed Sullivan Show* and at leading supper clubs such as the Hotel Fontainbleu in Florida and Grossingers in New York. However, Lavilli was also a highly talented athlete who played for the Boston Celtics, the New York Knickerbockers, and the Harlem Globetrotters. He was reputedly the only performer ever to have received coverage in the newspaper in the entertainment and sports sections on the same day. (Courtesy of Doris [Lavelli] Duff.)

Italian-American singers and recording artists Jimmy (Bono) Geany and Jerry Vale both specialize in performing Italian music. They are standing in Boston's City Hall Plaza in 1997. Geany resides in Medford. (Courtesy of Jimmy [Bono] Geany.)

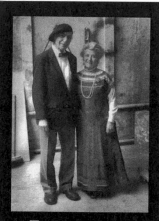

Italian Americans also made major contributions in the field of sculpture. A card advertises a 1995 exhibit of the works of Archangelo Cascieri, sculptor and long-time dean of the Boston Architectural Center, as well as those of his wife, Eda (di Biccari) Cascieri. Eda's brother, Adio di Biccari, is also a sculptor of considerable reputation. (Courtesy of Terri Mazzulli.)

Vincent Cerbone, pictured here in his workshop at the Museum of Fine Arts about 1975, arrived in America from Naples in 1931 at age 21, already a skilled cabinetmaker. He eventually became a director in charge of restoration in the Decorative Arts Department of the Boston Museum of Fine Arts (MFA) and came to be recognized as one of the world's preeminent restorers. At the MFA, Cerbone worked closely with another Italian-American master craftsman, upholsterer Andrew Passeri. Cerbone lived in Revere. (Courtesy of Roseann [Cerbone] Innes.)

Vincent Cerbone, at work at the MFA in 1970, restores a Japanned highboy, a task that no other MFA restorer had previously dared to tackle. He performed this task with such success and technical originality that other museum restorers immediately copied his techniques. (Courtesy of Roseann [Cerbone] Innes.)

Italians also attained considerable distinction in the field of education. Mark Francis Russo, who received his Master's Degree from Boston College in 1922, was the first Italian American on the Boston Latin School faculty, serving as head of the English Department from 1922 to 1961. Later, he served as head of its Audio-Visual Department. Mark Russo's students included the prominent historian Theodore H. White, who described Russo as "an unbelievably good teacher." (Courtesy of Jeanne [Russo] Richards.)

Marie (Marchi) Bonello graduated from Emmanuel College in 1941 with a degree in mathematics and physics. She later earned a Master's Degree from Boston College. A distinguished educator and author, she founded the New England School of Career Training in 1982. (Courtesy of Marie [Marchi] Bonello.)

Italian immigrants had a great interest in Italian-language Theater and often mounted plays in the various immigrant enclaves. An amateur theatrical company, most of whose members were from the Sandonatese communities of Brighton and Newton, is shown here performing an Italian-language drama at the Lithuanian Club on North Brighton's Lincoln Street in the late 1940s.

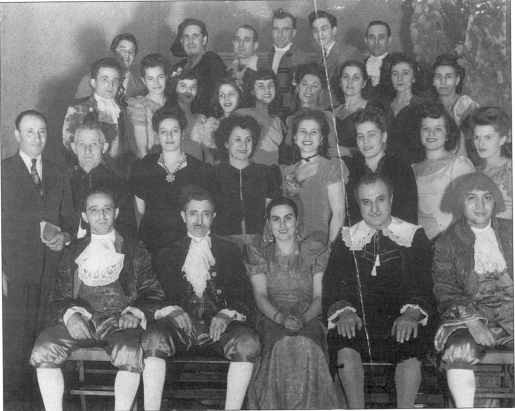

The 35 Boston-area members of the "Gruppo Folkloristico Ricordi d'Italia" stand outside St. Peter's Cathedral in Vatican City in authentic Italian regional costumes. Deeply committed to the preservation of traditional Italian music and dance, this Waltham-based group performs tarantellas, mazurkas, merlettos, quadriglias, tamburlettas, and other folk dances at international festivals, church fairs, dinner dances, and public functions. They have represented the United States at the International Folklore Festival held annually in Atina, Italy. (Courtesy of Margherita [DiDuca] Drake.)

The Dante Alighieri Society was founded in Italy in 1889 to promote Italian culture. The local branch dates from 1911. On December 10, 1980, ground was broken for the Pietro Belluschi-designed Dante Alighieri Society headquarters at 41 Hampshire Street, Cambridge. Participants in the ceremony include the following, from left to right: Dino Pasquale, State Senator Michael LoPresti, Dante President Samuel Ussia, Governor Edward J. King, Lieutenant Governor Thomas P. O'Neil, Former Governor John A. Volpe, Consul Vittorio Fumo, and Judge Joseph Ferrino. (Courtesy of the Dante Alighieri Society of Massachusetts.)

Ten

GOVERNMENT AND POLITICS

Government is a realm in which Italians faced formidable obstacles. Many complex factors worked against their progress in this area. For one thing, aspiring Italian Americans found public life in Massachusetts and in Boston firmly under the control of earlier-arriving Yankee and Irish residents. Each group was dominant in its respective sphere—Yankees at the state level and the Irish at the municipal level. Moreover, Italians suffered from strong negative stereotypes and a rather narrow base of registered voters.

This situation prevailed until after WWII. Then, major parties began to look for attractive Italian-American candidates to run for statewide office, reasoning that this would draw Italian votes to their statewide slates. It was in this context that Massachusetts began to elect its first Italian Americans to high public office. In 1956, Foster Furcolo, a Democrat from Longmeadow, became the state's first Italian-American governor. Furcolo's father, a prominent physician, had immigrated to the United States as a child from Sant'Angelo al l'Esca, Province of Avellino. Furcolo won reelection in 1958 by a wide margin.

In the next gubernatorial election, in 1960, another Italian-American governor was chosen. John Anthony Volpe, a Republican, had been a highly successful building contractor. Volpe was the son of immigrants from the Abruzzi region. Political conditions were so favorable to Italian-American candidates in statewide races by 1964 that both parties nominated Italian Americans as their gubernatorial candidates. The barriers to the election of Italian Americans to statewide office had definitely come down.

However, the rise of Italians to positions of political power in the city of Boston was a much slower process. In 1951, Gabriel Piemonte, a North End lawyer, became the first Italian to win a citywide race in Boston, capturing a seat on the newly created nine-member at-large City Council. On his first day in office, he was also elected president of that body, the first Italian American to hold the post. At one point in the 1970s, Italian Americans held four of nine seats on the Boston City Council.

The Boston Mayoralty was another matter, however. The candidacy of Italian Americans for mayor was long regarded as a hopeless quest. For more than 70 years, from the 1920s to the 1990s, every mayor of Boston had been Irish.

This state of affairs changed rather dramatically in 1993. In March of that year, Boston City Council President Thomas A. Menino of Hyde Park, the grandson of Italian immigrants, became Boston's first Italian mayor, when President Clinton appointed Raymond Flynn as U. S. Ambassador to the Vatican. In the regular city elections that fall, Menino not only prevailed,

but also garnered an amazing 65 percent of the vote. Then, in the next mayoral election in 1997, the popular chief was unopposed for reelection and became the first Boston mayor in modern times whose reelection was uncontested.

Other recent Italian-American political successes have included the election, in 1998, of Paul Cellucci as governor and of Somerville Mayor Michael Capuano to the eighth congressional district seat.

Judge Frank Leveroni immigrated to the Boston area from Genoa in 1884 as a child of five and grew up in the North End. A 1903 graduate of Boston University, Leveroni was one of the first Italian-American lawyers in Boston and the first Italian appointed to a judgeship in Massachusetts. In 1906, Leveroni was named a Special Justice of the Boston Juvenile Court, a position he held into the late 1940s. Judge Leveroni resided in Jamaica Plain.

Vincent Brogna immigrated to Boston from Montefalcione, Avellino Province, at age four in 1891 and grew up in the North End. He later became the first Italian to be appointed to the state's highest court, the Massachusetts Supreme Judicial Court. Judge Brogna was a 1928 graduate of the Boston University School of Law and resided in Newton.

This photo was taken at an Italian-American Bar Association meeting on November 19, 1943. The following are pictured from left to right: (seated) Judge Frank Leveroni, Frank Farley, and State Superior Court Justice Felix Forte; (standing) Judge Alfred Sartorelli, Judge Ignatius R. Brucato, and Judge Frank Tomasello. Felix Forte was the most distinguished of the Italian-American judges. A graduate of Boston University and Harvard Law Schools and a professor of law at Boston University and author of several books on law, Forte was appointed to the Supreme Judicial Court in 1939. (Courtesy of the Boston Public Library.)

The most successful Italian politician of the early part of the 20th century was Andrew Casassa of Revere. A graduate of the Boston University School of Law, the 26-year-old lawyer was elected to the Massachusetts House of Representatives in 1912. In 1920, he was sent to the state senate, becoming the pioneer Italian member of that body. He then capped his political career in 1930 by winning election as mayor of Revere, becoming the first Italian-American mayor in Massachusetts. Casassa held that office until 1934. (Courtesy of Peter McCauley.)

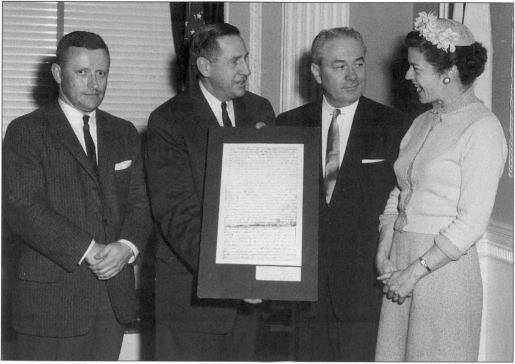

Foster Furcolo, pictured here in his State House office (holding the document), was elected the first Italian-American governor of Massachusetts in 1956. To Furcolo also belongs the distinction of being the first Italian American from Massachusetts elected to the U.S. House of Representatives, a post he held in the early 1950s.

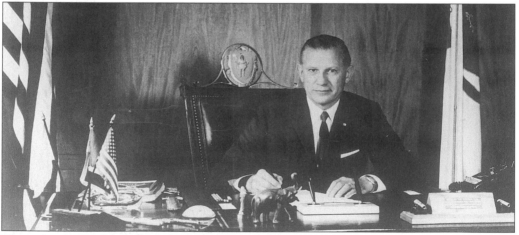

The most successful Italian-American political figure in Massachusetts history was John Anthony Volpe, who served as governor from 1961 to 1963 and from 1965 to 1969. Volpe was born in Wakefield in 1908, the son of immigrants from the mountain village of Pescosansonesco in the Abruzzi. A highly successful building contractor, he served as Massachusetts Commissioner of Public Works from 1953 to 1956, and as Federal Highway Administrator under President Eisenhower from 1956 to 1957. Volpe also served as U.S. Secretary of Transportation from 1969 to 1972 and as U.S. Ambassador to Italy from 1972 to 1977. (Courtesy of the Massachusetts State Library.)

Henry Scagnoli was the first Italian American to head a major department of Boston's city government, having been appointed fire commissioner in 1960 by Mayor John Collins. Subsequently, Scagnoli served as the city's director of administrative services, or deputy mayor, a post he held until 1968. Here, city clerk Walter Malloy swears in Scagnoli as fire commissioner. Scagnoli, the son of immigrant father from the Molise region, grew up in Jamaica Plain and graduated from Northeastern University with a degree in business administration. (Courtesy of Henry Scagnoli.)

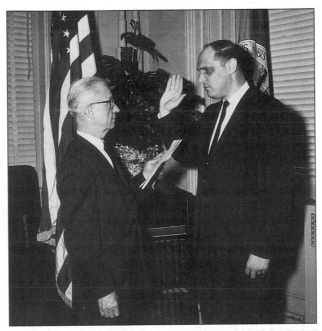

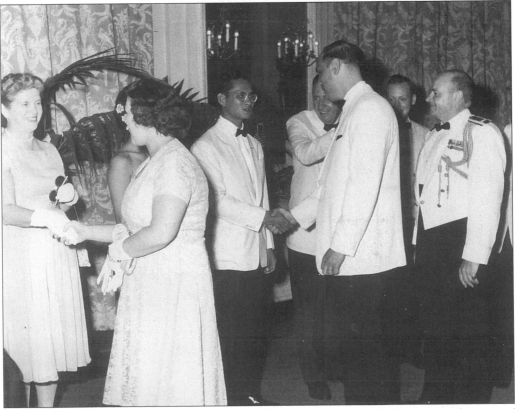

Deputy Mayor Scagnoli extends the greetings of the city of Boston to the king and queen of Thailand during a royal visit in 1960. To the immediate left of Scagnoli stands Governor Foster Furcolo. (Courtesy of Henry Scagnoli.)

Not until 1993 did Boston have its first Italian mayor, Thomas M. Menino, who had previously served as a district city councilor from Hyde Park and as city council president. Menino inherited the office when his predecessor, Raymond Flynn, was named U.S. Ambassador to the Vatican in March 1993 but went on to win election in his own right that fall by a commanding margin. So popular has this first Italian-American mayor of New England's largest city proven to be, that in 1997, he was reelected without opposition, the first time in this century that that has occurred. Menino, the grandson of immigrants from the Naples area, grew up in the Hyde Park section of the city, a neighborhood that contains a substantial Italian-American population. (Courtesy of the Office of the Mayor of the City of Boston.)

The state's second largest city, Worcester, also has an Italian-American mayor, Raymond V. Mariano. The oldest of nine children and the son of an immigrant mother and a father who is a totally disabled war veteran, Mariano graduated from Worcester State College and holds a degree in public administration from Clark University. A member of the Worcester School Committee and City Council before his election as mayor in 1993, Mariano is currently serving his third term as Worcester's chief executive. (Courtesy of the Office of the Mayor of the City of Worcester.)

U.S. Congressman Michael E. Capuano was elected to Massachusetts historic Eighth Congressional District seat in the U.S. House of Representatives in 1998, the first Italian American to hold that post. Capuano grew up in Somerville and graduated from Dartmouth College and Boston College Law School. The congressman's father, Andrew Capuano, was the first Italian American elected to a public office in Somerville's history. Before his election to Congress, Capuano served as a member of the Somerville Board of Aldermen (occupying the same seat his father had previously held) and as a popular five-term mayor of the city. (Courtesy of the Office of U.S. representative Michael E. Capuano.)

State Senate President Thomas Birmingham administers the oath of office in the House of Representatives chamber to Governor A. Paul Cellucci in January, 1999. (Courtesy of the Office of the Governor of Massachusetts.)

The current governor of the Commonwealth, A. Paul Cellucci, is the third Italian American to hold that post, having succeeded to the governorship with the resignation of Governor William Weld in 1998. In November of the same year, he won the office in his own right. Cellucci, who grew up in Hudson, is the grandson of Argeo L. Cellucci, who was born in Anzio near Rome in 1898, and who immigrated to America in 1912. (Courtesy of the Office of the Governor of Massachusetts.)